The Beautiful and the Damned

THE CREATION OF IDENTITY IN
NINETEENTH CENTURY PHOTOGRAPHY

Peter Hamilton | Roger Hargreaves

LUND HUMPHRIES
in association with
THE NATIONAL PORTRAIT GALLERY, LONDON

First published in 2001 by
Lund Humphries
Gower House
Croft Road
Aldershot
Hampshire GU11 3HR

AND

131 Main Street
Burlington
VT 05401
USA

In association with

National Portrait Gallery Publications
National Portrait Gallery
St Martin's Place
London WC2H 0HE

On the occasion of the exhibition
*The Beautiful and the Damned: The Creation
of Identity in Nineteenth-Century Photography*
at the National Portrait Gallery
6 June – 7 October 2001

Lund Humphries is part of Ashgate Publishing

COVER IMAGE
Arthur Batut, *Male Members of the Family of Arthur Batut* (detail),
Musée Arthur Batut

BACK COVER IMAGES
Alexander Bassano, *Ellen Terry, Actress* (detail), modern print
from negative, National Portrait Gallery (x96389)

G.-B. Duchenne de Boulogne, taken from *Mécanisme de la
physionomie humaine*, 1862 (detail), salted paper print pasted on card,
© Ecole Nationale Supérieure des Beaux-Arts, Paris

Alphonse Bertillon, *Georges Bertillon Jnr, Aged 2* (detail), © Musée
des Collections Historiques de la Préfecture de Police, Paris

Unknown photographer, Victor Prevost arrested and sentenced to
death for the murder of a jewelry dealer, 1879 (detail), © Musée des
Collections Historiques de la Préfecture de Police, Paris

British Library Cataloguing-in-Publication Data
A catalogue record for this book is available from the British Library

Library of Congress Control Number: 2001088090

Hardback ISBN 0 85331 821 2 (Lund Humphries)
Paperback ISBN 1 85514 309 7 (National Portrait Gallery)

Picture Research by Cally Blackman
Designed by LewisHallam
Printed in Italy by EBS

Contents

Acknowledgements

This book could not have been written without the help and advice of many people and the support of the institutions for which we work. Peter Hamilton's research was aided by a generous grant from the Open University's Culture and Governmentality Research Group within the Sociology Department. Our joint thanks are also due to the National Portrait Gallery and its Education Department, which offered the resources necessary to assemble and mount the exhibition – the initial impetus for the book.

We learned a good deal about the uses of photography in the nineteenth and twentieth century through the generous help of many scholars and experts in the field. The project as a whole could not have been given its form as an exhibition and a book without the aid of the people we would like to mention here. They include, amongst our colleagues at the National Portrait Gallery, Terence Pepper (Curator of Photographs), John Cooper (Head of Education), Kathleen Soriano (Head of Exhibitions and Collections Management) and Jude Simmons (Senior Exhibitions Designer). We would also like to thank David Allison at Hulton Getty, Russell Roberts and Brian Liddy at the National Museum of Photography, Film and Television, Pam Roberts at the Royal Photographic Society, Felicity Ball at the Prison Service Museum, Mark Haworth-Booth at the Victoria and Albert Museum, Stanley Burns M.D. and Elizabeth Edwards at the Pitt Rivers Museum Research Centre, Oxford, Serge Nègre of L'Espace Photographique Arthur Batut, Arek Bentoski at the Royal Anthropological Institute, Mike Seaborne at the Museum of London, David Cross at the West Midlands Police Museum, Patricia Allderidge at the Royal Bethlem Hospital Museum, Yannick Vigouroux at the Patrimoine de la Photographie, Paris, Isabelle Astruc and André Le Cudenec at the Musée de la Préfecture de Police, Paris, Christiane Dole at the Musée Carnavalet, Catherine Prade at the Musée National des Prisons, Fontainebleau and Adam Perkins and the staff of the manuscript department of Cambridge University Library. Our thanks also go to Anne Fourcroy, Gerard Levy, Gina Kehayoff, Michael Wilson, Violet Hamilton, Sophie Taysom and Dr John Wilson, and many others in various archives, libraries and institutions in Britain, France and America, who have helped with this book or lent works to the exhibition.

Considerable editorial assistance was provided by Jacky Colliss Harvey and Anjali Bulley at the National Portrait Gallery. Lucy Clark and Lucy Myers of Lund Humphries contributed their editorial skills too. We would also like to give special thanks to Cally Blackman, the book's picture researcher.

Finally, we offer the disclaimer that none of those mentioned should be held responsible for any of the opinions expressed in this book, which are entirely those of the authors.

Peter Hamilton, Oxford
Roger Hargreaves, London
FEBRUARY 2001

Foreword

I have always believed that national museums have a responsibility to stage exhibitions which do not only show work in a conventionally popular way, but also suggest new ways of thinking about a subject. The National Portrait Gallery's exhibition, *The Beautiful and the Damned*, is just such a show.

Both the exhibition and this book which accompanies it look at two familiar, but traditionally seaparate, forms of early photography. On the one hand, the social and cultural implications of early studio photographs and how the manners and mores of the Victorian middle classes were recorded in daguerrotype and collodion are investigated. On the other hand, the opportunities which the medium afforded for new systems of scientific classification are examined. By comparing these two different types of photograph – one of the beautiful, the other of the damned – each helps to inform the other. The *carte de visite* ceases to be an innocent aide-mémoire and becomes an instrument of Darwinian science. The Strachey family on their knees at prayer are transformed into biological specimens. Meanwhile, a photograph of a mental patient is seen to share the same characteristics as Julia Margaret Cameron's famous photograph of Tennyson.

So, *The Beautiful and the Damned* helps to inform us of the ways in which photography has transformed our view of the world. I feel sure that it will challenge our understanding of the early history of photography and encourage visitors and readers to think about photography in new ways.

Charles Saumarez Smith
DIRECTOR

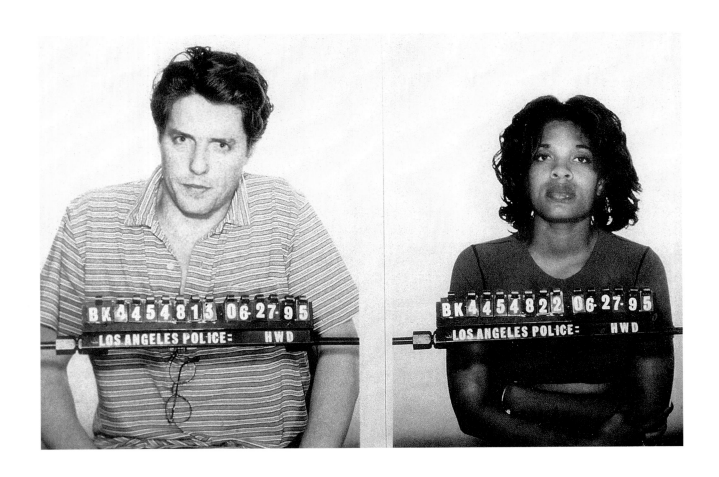

fig.1 Los Angeles Police Department
Hugh Grant and Divine Brown, 27 June 1995
© LAPD

CHAPTER I

The Beautiful and the Damned

PETER HAMILTON

On 27 June 1995 the actor Hugh Grant and the prostitute Divine Brown were arrested and charged with lewd conduct for publicly performing an act of indecency in a parked car. The Los Angeles Police Department (LAPD) saw in this the perfect opportunity to promote their policy of naming and shaming male miscreants and made the arrest photographs of the pair freely and instantaneously available to news editors around the world. Celebrity and crime have been the sure money of newspapers since photography and the press became indelibly intertwined in the early 1900s. Sales being always guaranteed on the rare occasions when the two could be linked within the same story. The unexpected appearance of one of the LAPD's photographs both surprised and delighted the following day's readership and elevated the image to the ranks of the most memorable and iconic portraits of that decade. It contained the two perfect ingredients for the come-uppance of celebrity: embarrassment and a salacious crime in which the perpetrator becomes the principal victim. That Grant should have made his name as a performer of foppish English public-school types only added to the amusement. At the root of the public's fascination was the instant recognition of both the celebrity and the portrait style in which he had been so incongruously placed.

As the example of Brown and Grant shows, photography has become both a trusted method of establishing identity and a key medium for promoting celebrity. Once their photographs had been circulated via the media, Brown became, briefly, a celebrity, whilst Grant was further confirmed as one. The event that brought them together in the public mind was not in fact their 'sordid' transaction, but its reporting by the mass media, with the support of the mug-shots used to witness their brief union. It thus entered the public domain as a 'celebrity scandal'.

We are used to seeing photographs of celebrities such as Hugh Grant flit across the TV screen and snap into view on the printed page. Such images are merely part of the currency of celebrity, without which it could not thrive. They supply the vital lifeblood of recognition, reminders of the facial distinct-iveness of the person celebrated. But we are also accustomed to another sort of likeness, that which adorns our passports, driving licences, identity cards and

fig.2 Alexander Bassano
Sir Henry Hawkins
Modern print from negative
National Portrait Gallery (x76245)

fig.3 Alexander Bassano
Sir Henry Hawkins
Modern print from negative
National Portrait Gallery (x76236)

so on. The mug-shots of Hugh and Divine, simple records of their facial like-ness made at the time of their arrest, are exactly the same type of photograph as any banal image we might find in our own wallets attesting to identity and thus also concerned with recognition. But in this case the mug-shots take on a new meaning, linking celebrity to scandal, identifying forever these two protagonists in an urban encounter which otherwise would be, despite its illicit nature, hardly remarkable at all. In effect what has happened is that, in the case of Divine Brown and Hugh Grant, two systems of what we might call 'surveillance' have combined. The first system of surveillance subjects notable individuals to generally positive forms of public scrutiny, a process in which they largely connive. Celebrity photographs and their use in the media are really no more than a form of surveillance, but one which the subject has a clear interest in supporting: it increases the public saliency of their face, and by extension their fame and renown. This may then translate into material advantage or cultural status (and often both). It is easy to see why the acting profession has had a love affair with photography since its invention, and also why artists such as Pablo Picasso (1881–1973) or Tracey Emin (born 1963) have been so welcoming to the camera's gaze.

The cult of personality now so evident within contemporary mass media has its roots in the Classical period, and is deeply anchored within western society's concepts of beauty, fame, heroism and virtue (Rojek, 2001). But at the same time there is (and has been for a very long time) another side to the symbolic coin of celebrity – for no concept really makes sense unless we can

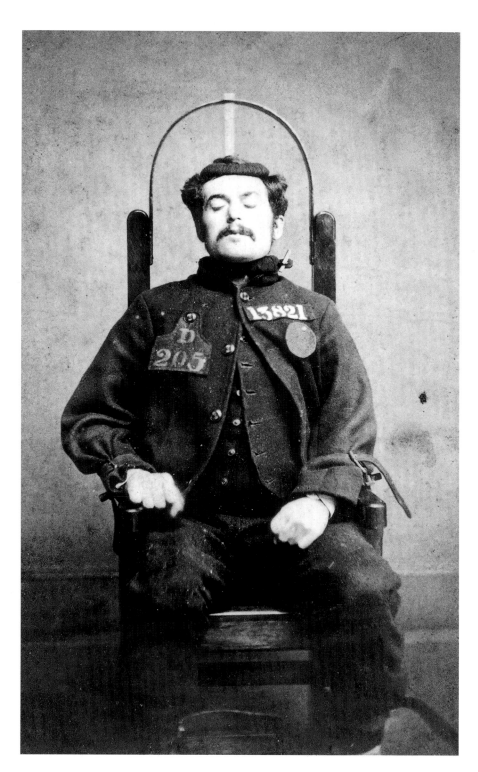

fig.4 Dr Henry Clark
*Inmate, Prisoner No.347834.15, West
Riding Prison, Wakefield, c.1869*
Albumen print
© Wellcome Library, London

The earliest uses of photography to
record criminals dates from 1841–2,
but such pictures are indistinguishable
from portraits made for other purposes.
The use of devices to standardise the
judicial image, such as this means of
restraint, indicates the increasing need
to draw quantifiable and evidential
data from the photograph, made
evident from the 1860s.

imagine its opposite. Against celebrity and its positive attributions of beauty, fame and wealth are set negative characteristics. In this process of binary opposites, the ugly, the notorious, the cowardly and the evil also have their parts to play. For them was devised another system of surveillance, and in the nineteenth century it increasingly forms part of scientific knowledge. It is a mode of surveillance through photography in which faces are captured in order to classify and control them within an archive or 'database'. Each mode of surveillance, then, is defined not simply by the process of photographic portraiture, or even by the reason why the picture is made. What differentiates them are the uses to which they are put, their roles in wider systems of social classification.

It seems hardly accidental that the history of celebrity portrait photography and the history of the scientific uses of the portrait as a tool of social order run hand in hand. For each of them, a clearly motivating force is that of classification, the abiding obsession of nineteenth-century thought. Both systems of surveillance have their origins in the early days of the medium, and both

fig.5 Benjamin Stone
Harry Marks, 1899
Platinum print
National Portrait Gallery
(x44868)

fig.6 Benjamin Stone
*Miss Majorie Barabel Ruth
McIver, daughter of Sir
Lewis McIver, MP*, 1899
Platinum print
(mounted on card)
National Portrait Gallery
(x44865)

fig.7 Benjamin Stone
Charles Sefton, 1909
Platinum print
(mounted on card)
National Portrait Gallery
(x44953)

developed from the same sources. In just more than half a century, photography became the dominant medium of visual representation in western society. This book is concerned with the fascinating history of the portrait photograph in the nineteenth century. Our aim is to present some examples of how social portraiture and scientific photography can be understood as different facets of the nineteenth-century fascination with social classification and order.

Social order and social classification

The invention of photography in 1839 took place at a time when novel forms of industrial production were beginning to get into their stride. In technological terms, photography was not at first dependent on a complex industrial process. It was in many ways an innovation that might have emerged much earlier. All the elements – chemical and optical – were in place by the second half of the eighteenth century. Early photography using both the unique

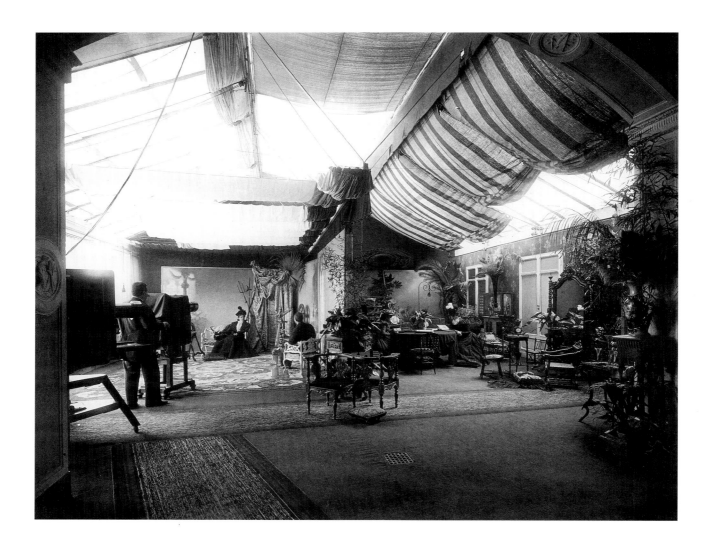

fig.8 Fratelli Alinari
*Alinari 'Sala di posa' Portrait
Studio, c.*1900s
© Archivi Alinari, Firenze

The photography firm of Alinari was
founded in Florence in 1852. It was
typical of the larger factory-style studios
that opened up in the major cities of
Europe and America to capitalise on
the new opportunities offered by
the wet collodion process. Alinari
specialised in society portraits, casting
its clients against a rich array of props
and backdrops lit by natural light
subtly controlled by screens, blinds
and reflectors. In addition to its
portrait business, the firm developed
a flourishing trade in making photo-
graphic copies of the art treasures of
northern Italy.

daguerreotype and the reproducible calotype was little more than a scientifically inspired craft process typical of Enlightenment technology, costly and complicated yet capable of making individual images of extraordinary beauty. Emerging fifty years earlier, it might have remained a curiosity only afforded by the wealthy aristocracy. But its success was due in large part to the fact that it appeared at a time when a new 'middle class' was emerging throughout Europe and America, a social group which saw photography as the ideal medium to represent its own visual identity.

Until the final moments of the eighteenth century, people in western societies had been stratified by status and hierarchy, rank and order. Social groups and individuals stood, as they had done for perhaps 200 years, in

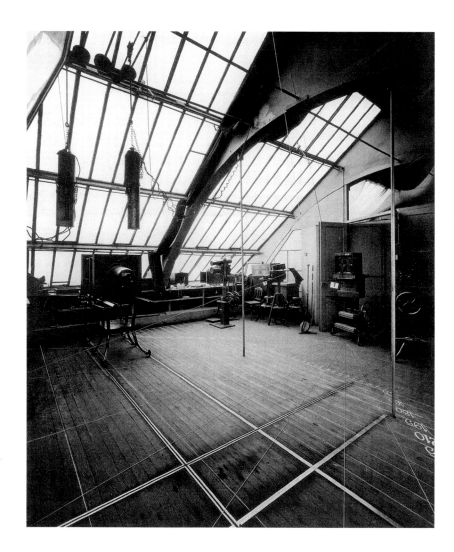

fig.9 Alphonse Bertillon
*Studio de la Préfecture de Police, c.*1890
Silver print mounted on
classification card
© Musée des Collections Historiques
de la Préfecture de Police, Paris

The *atelier photographique* (studio)
of the Préfecture de Police in Paris,
*c.*1890. Alphonse Bertillon's use of
photography as the final element in
a systematic means of identification
relied upon precise observation,
measurement and classification.
This studio, of the Police Headquarters
in Paris, was also used for training
operators in the techniques of
bertillonage, a simple card-based system
complemented by a systematic photo-
graphic technique of strict uniformity.

fig.10 W. & D. Downey
*Gladys, Countess de Grey, later
Marchioness of Ripon*, 1897
Photogravure
National Portrait Gallery (AX41225)

The portrait of Lady de Grey was
made to mark her appearance in
the costume of Cleopatra at the
Devonshire House Ball in 1897. This
grand and exclusive society event,
with a guest list headed by the Prince
and Princess of Wales, was held in
celebration of Queen Victoria's
Diamond Jubilee. James Scott Lauder
(Lafayette) set up a makeshift studio in
a marquee to photograph many of the
guests, while others took themselves
and their costumes to their favoured
photographers. The photographs were
published in a commemorative album
of photogravures in which the guests
are re-assembled and appear as
unreachable social exotics, as strange
and remote as any anthropological
study of the period.

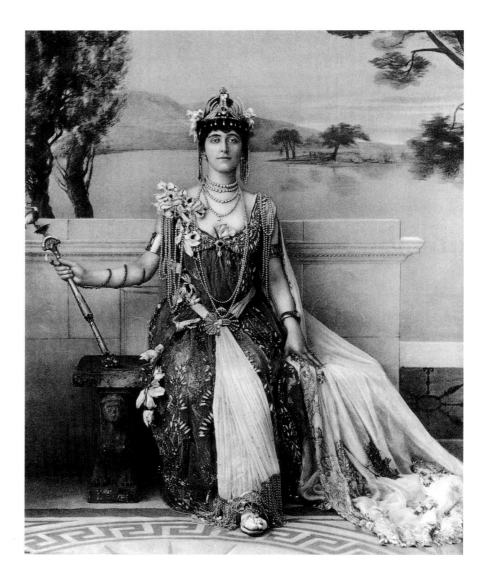

conventionally accepted relationship one to another, forming a great chain
that went from the lowest to the highest. In the 1690s, Gregory King
(1648–1712), the English genealogist, engraver and statistician produced
his *Natural and Political Observations and Conclusions Upon the State and
Condition of England* (1696). It provides the best available picture of England's
population and wealth at the end of the seventeenth century. This novel
attempt to census the population of England places 'temporal lords' at the
top and 'thieves and vagrants' at the bottom. Although there were distinct
differences between individual societies within countries such as France and

Britain, the general pattern was everywhere much the same. It was thought of as an immutable (even divine) order, held together by the distribution of property: land, capital, goods, tools, and so on, but offices (such as those in the government, church or judiciary) and forms of personal liberty could also be a type of property. The kind and amount of property a person owned determined their position within the social order, itself held together in an organic manner, with bonds of obligation or deference flowing from one group to another, down and up. Royalty was at the top, the aristocracy came next, and so forth down to the lowliest labourer. A common metaphor for society was the physical body, with the body politic being likened to the head, and the other aspects of society being the various limbs. If threatened (from above or below), disorder or death might follow. It is intriguing to wonder how such a society would have been photographed, had the medium been invented earlier. (One clue to this is Granger's 1769 method for ordering engraved portraits of historical figures, discussed in more detail in Chapter Two.) But one thing seems clear: society would have looked rather different to that which we see in nineteenth-century photography.

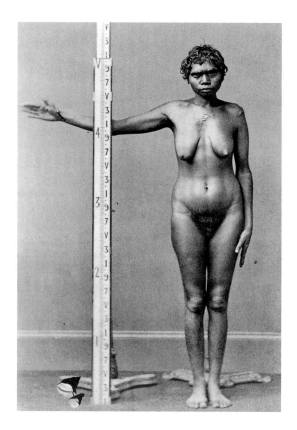

fig. 11 Unknown photographer
Anthropological Study of a South Australian Aboriginal Female ('Ellen' aged twenty-two), c.1870
Albumen print
Courtesy of the Royal Anthropological Institute of Great Britain and Ireland

The invention of photography and the formation of the 'Aboriginal Protection Society' (later Royal Anthropological Institute, where this photograph was found) took place within two years of each other. Much early anthropological photography sought to make records of 'aborigines' as if they were dying breeds. By the late 1860s, there was increasing interest in finding 'quantifiable' information in the photograph, hence the use of a measuring stick in this photograph. It forms part of the recording of a family group of aborigines, all of whom are recorded in a similar way.

By the first quarter of the nineteenth century, the traditional social order in most of the leading nations of the West had been supplanted to a large degree by the formation of distinct social classes, defined less by the kind of property they owned than by what Karl Marx (1818–83) (using a concept defined by certain English economists of the eighteenth century) famously called 'relationship to the means of production' (Marx and Engels, 1848: 1962, p.23). The extensive development of trade and industry transformed western societies into class societies in which social relationships of most, if not all, types were increasingly dominated by material considerations – with the large mass of workers concentrated in towns or near factories and other places of work, a small elite of business- and land-owners running enterprises producing goods for a market, and a growing and diverse middle class of professionals, administrators, shopkeepers, independent artisans and small or 'peasant' farmers. Factory production ensured an ever-increasing range of mass-produced commodities and led to the creation of a consumer market which gave rise to the invention of most aspects of modern life we now take for granted: advertising, the department store, street lighting, public transport, to name only a few. Alongside these innovations, photography supplied another: a means of defining, visually, the distinctions between the new social classes of the nineteenth century, a method of fixing the characteristics of each of the trades and professions which were then emerging. In an era which promoted professionalisation in particular, the status which went with the new position was increasingly affirmed by the photographic portrait. Enterprising photographers and publishers exploited the market for part-works through the assembly of portraits of the leading figures of the day in titles such as *Men of Mark* (1875–83).

A new form of society could not emerge without related changes in such key institutions as marriage and the family. There is plenty of evidence that the early nineteenth century saw a rising interest in formally conducted marriage services, boosted in Britain by the wedding in 1837 of Queen Victoria to Prince Albert. The middle classes wanted to affirm their respectability, their material success, their distinctive values concerning marriage and the family, and saw in photography a means of displaying these assets. They wanted on the one hand to link themselves to the upper classes and nobility, whose material culture they envied but whose morals and excesses they often abhorred, and on the other hand to distinguish themselves from the labouring classes, whom they saw as social inferiors.

Photography offered the middle classes a new means of being represented both as individuals and as a group. But it also answered a deep longing for keepsakes of loved ones in a period when distance and death separated people far more frequently than they do now. As an example, we find the poet Elizabeth Barrett Browning (1806–61) writing in 1843 to a friend:

My dearest Miss Mitford, do you know anything about that wonderful
invention of the day, called the Daguerreotype? – that is, have you seen any
portraits produced by means of it? […] And several of these wonderful
portraits, like engravings – only exquisite and delicate beyond the work of
graver – have I seen lately – longing to have such a memorial of every Being
dear to me in the world. It is not merely the likeness which is precious in such
cases – but the association, and the sense of nearness involved in the thing, the
fact of the very shadow of the person lying there fixed for ever! It is the very
sanctification of portraits I think – and it is not at all monstrous in me to say
what my brothers cry out against so vehemently, … that I would rather have
such a memorial of one I dearly loved, than the noblest Artist's work ever
produced. I do not say so in respect (or disrespect) of Art, but for Love's sake
[…] (quoted in Henisch & Henisch, 1994, p.166).

Photography preserved the dearly loved's likeness in perpetuity. This was
a significant matter in an age when the emotional investment made in the
family was growing. Yet it was also a period of high infant mortality and,
more significantly, a time when, as one historian of childhood has pointed out,
children shifted from having low economic worth to embodying 'priceless'
emotional value (Zelizer, 1985, pp.8–11). Whereas in the 'pre-industrial' period
from the fifteenth to the late eighteenth century the family and the household
seem to have been relatively undifferentiated social concepts, with live-in
servants, apprentices or lodgers usually considered to be family members
though not perhaps with property rights, by the early nineteenth century a
new model was emerging (Laslett, 1965, pp.1–22). Hitherto, in a largely agri-
cultural economy, the entire family had worked to support itself: this included
even quite young children. But as industrialisation and trade led to the
creation of large enterprises, urbanisation and new forms of housing, there
was an increasing focus on the importance of creating a stable 'nuclear family'
– parents and children, occasionally with older relatives and unmarried adults
residing with them. Such a unit fitted better with an industrial economy's need
for wage labour. Emotionally, too, the emphasis shifted: from marriages founded
on common work or property interests to the ideal of the 'companionate
partnership', symbolised in many ways in Britain by Queen Victoria and
Prince Albert. The ideal of the 'love-marriage' was promoted in fiction and
increasingly came to underpin relations between men and women. Indeed,
as much Victorian writing demonstrates so clearly, there was a marked
increase in ideas about romance and in sentiment, towards lovers and
children, but also towards other members of the family. The family became
defined less by the material interdependence of its members than by their
emotional links one to another. Yet despite these trends the 'nuclear family'
model was also characterised by patriarchy: a heavily male-centred model in
which (until the late nineteenth century) women did not control the property

fig.12 Sir Emery Walker
*National Portrait Gallery at Bethnal
Green Museum*, *c.*1880
Silver print
National Portrait Gallery
(Muniment store)

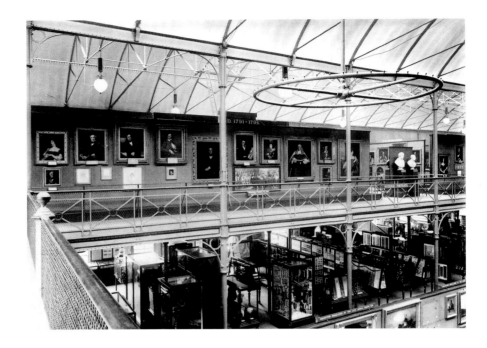

they brought with them into a marriage and were subjected to male authority in most domains.

The emotional centrality of the family – nuclear as well as extended – as the key building block in nineteenth-century western society offers a clue to the extensive use of photography to idealise and memorialise this social institution. Sometimes this could be seen most clearly when death intervened. Jay Ruby has shown in his study of postmortem and funeral photography that when a person was 'missing' (for whatever reason), another device would be found to include them in the family likeness (for instance, by showing other members holding a picture of the person) (Ruby, 1995, pp.60–3). But there are also many sad images of parents photographed with their dead child, or mourners by the bedside of a dead adult. The currency and emotive force of such images is further demonstrated by the fact that 'art' photography also dealt with such subjects, a noted example being that of Henry Peach Robinson's *Fading Away* (1858) which depicts a scene of imminent death, a beautiful young woman lying on a chaise longue, surrounded by mother, father and sister as her last moments slip away. As this example indicates, photography supplied a widely distributed need within nineteenth-century society for ways of memorialising the cherished dead, seemingly in a manner which painting was incapable of reproducing. Indeed postmortem photography is itself an index of the increasing emotional investment people were

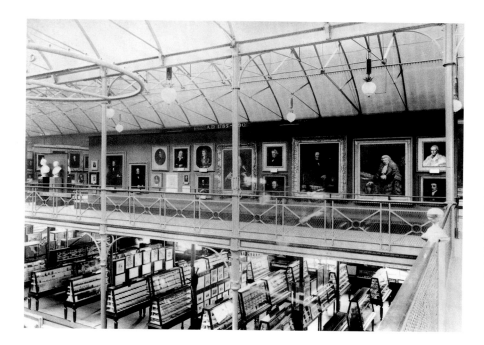

fig.13 Sir Emery Walker
*National Portrait Gallery at Bethnal
Green Museum, c.1880*
Silver print
National Portrait Gallery
(Muniment store)

The National Portrait Gallery enjoyed
a nomadic existence in the period
between its foundation and the opening
of its own purpose-built gallery in
1896. Following a fire at South
Kensington, it was moved to Bethnal
Green – together with miscellaneous
collections from the Department of
Science and Art. The serried ranks of
portraits exhibited in glass display cases
visible on the floor below mirror the
Victorian passion for classification.

making in their loved ones. Sometimes the lead for this came from above, as
in the case of Queen Victoria and Prince Albert, who allowed the distribution
of photographs of themselves by the leading photographers of the day, from
Roger Fenton (1819–69) to the studio of Downey, as model, doting parents, an
ideal family centred on the father but tied together by strong emotional links.

Photography had proved enormously successful with the royal families of
Europe. The mid-nineteenth century was the age of 'bourgeois nationalism'
in all European societies, a period during which liberal, middle-class groups
sought a greater democratic say in the running of their countries, and more
control over the monarchies and aristocratic elites that ran them. Hereditary
monarchs could no longer rely on absolutism to retain their position (the
demise of Louis XVI was still recent enough to remind them that they were
all too mortal). They needed to cultivate popular support if their considerable
power and wealth was to remain under their control. This is in part why
Napoleon III of France (1803–73) and Queen Victoria and Prince Albert in
England increasingly used photography in the 1850s and 1860s as a means of
representing themselves as 'middle-class' figures. Showing that they shared
the tastes and social mores of the middle classes was an effective way of
increasing their legitimacy amongst electors and the population at large.
Their use of this medium to disseminate positive images (both through the
press, which used photographs as the basis of engravings, and through the

mass sales of *cartes de visite* to mainly middle-class collectors) helped in turn to fuel the demand for photography.

The increasing demand for photography was not felt in respect of social portraiture alone. Indeed the wider culture of nineteenth-century western society seems more generally to have been in thrall to the idea of visualisation:

> observation, vision, display and spectacle, whether in photography, department stores, colonial exhibitions or scientific drawings, were intrinsic to its cultural processes and values, redrawing the boundaries of experiential knowledge and its institutional apparatus (Edwards, 1998, p.24).

Science seemed to promise that the whole universe would soon be opened up to scrutiny. Moreover the impact of scientific technology on industry was plain for all to see, as, for example, trains made it possible to travel from London to Paris in ten hours (a journey narrated by Charles Dickens (1812–70) in the 1850s). Provençal vegetables began to be transported along regular routes to the market stalls of Les Halles in Paris and Covent Garden in London within the same decade. Central to the increasing faith in scientific progress as the motor of economic growth and social improvement was the idea that empirical methods of observation and experimentation were the keys to wider knowledge.

Photography rapidly became a basic tool in the equipment of nineteenth-century science. As industrialisation advanced, there was increasing justification for belief in the utility of empirical methods, on experimentation and observation as central practices of scientific method designed to create universally available evidence. It seemed to many in the mid-nineteenth century that such scientific knowledge could be put to practical use in virtually every field of human enterprise. This was particularly important for the new institutions – museums and galleries – which would educate both the general public and specialists in the applications of such knowledge.

These institutions were universally considered to be essential to the tasks of educating and training (and even morally improving) a modern population (Bennett, 1998, pp.345–7). If science could readily be applied to all fields of human enterprise, it should also be able to answer even the most intransigent of social or biological questions. It might alleviate crime, prevent social disorder, eradicate physical disability. That certain forms of portrait photography became central to such aims goes some way to demonstrate the faith the era placed in its powers of depiction. As Oliver Wendell Holmes' (1809–94) apt reference to the daguerreotype would have it, photography was seen as a 'mirror with a memory' by many leading thinkers of the century, including Charles Darwin (1809–82). Indeed the term 'photography' itself was widely used as a synonym for objective knowledge: reporters from a variety of fields

included the word as a way of announcing that what they had done was to bring back an accurate account.

A closer examination of nineteenth-century photography, therefore, is revealing of the ways in which it became caught up with the dominant social, political and scientific ideas of the age. It is particularly clear that the developmental trajectory of scientific and pseudo-scientific photography of the human face and body mirrors that of art and social portraiture. Ideals of physical distinction, character, and beauty grounded in the Classical era and a defining feature of academic portrait painting still held sway at the beginning of photography, but were subject to increasing challenge as the century wore on. Conventions established in one area influenced modes of depiction in the other, so that we can see the fascination with phrenology and physiognomy moulding styles in studio portraiture as well as approaches to the anthropology of subject races, the diagnosis of mental disease, or the identification of criminals. The growing systematisation of photographic documentation of the human face during the nineteenth century 'feeds back' into social portraiture, with the latter used to present ideals of European society to which each family or individual could compare itself. Photography offered a means for creating systems of inclusive classification which would incorporate ever more sophisticated distinctions. The huge success of the *carte de visite* from the mid-1850s is part of this process, and was used as systematically to provide 'scientific' portraits (for instance of mental patients in the West Riding Lunatic Asylum of Wakefield) as it was to record the features of Queen Victoria and her family. Later, the emergence of systematically produced and quasi-classificatory sets of portraits of leading (and less exalted) figures of the age – such as figures in the part-work *Men of Mark* – had as its counterpart the collection of anthropological, medical and judicial portraits designed to record, classify and control subject races, degenerate bodies and deviant individuals.

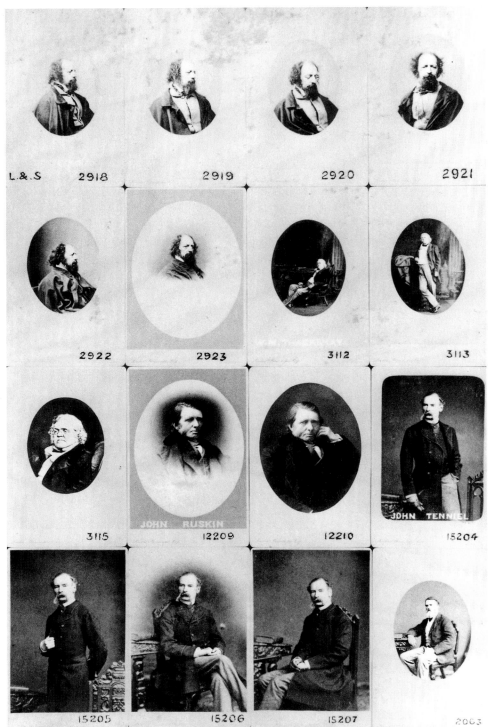

fig.14 Various photographers
including John and Charles
Watkins
Lord Alfred Tennyson,
William Makepeace Thackeray,
John Ruskin, Sir John Tenniel
and Tom Taylor
London Stereoscopic & Co. Ltd
Literary and Scientific Series,
Daybook, p.6, 1861
© Hulton Getty

CHAPTER II

Putting Faces to the Names: Social and Celebrity Portrait Photography

ROGER HARGREAVES

The social context of photography

Until relatively recently the history of photography has been defined by two dominant narratives, those of science and art. The first has sought to trace a series of technological developments, often overlapping one-another, in the steady march towards a sophisticated medium capable of creating instant-aneous pictures, rich in detail and with the capacity for almost infinite reproduction. The parallel narrative on art is constructed around a pantheon of star photographers from the nineteenth century; men and women who are perceived to have marked each phase of development by the quality and originality of their work. Names such as Antoine Claudet (1795–1867), Nadar (1820–1910) and Mathew Brady (1823–96) would have been recognisable in their own age while others, such as Lady Clementina Hawarden (1822–65), Julia Margaret Cameron (1815–79) and Eugène Atget (1857–1927), were only subsequently elevated to the celestial firmament from their contemporary positions of relative obscurity. Taken together their names have been plotted on the baton charge down history towards the consideration of photography as fine art.

There is, however, a third and more recent history, incorporating elements of the previous two, that seeks to define the economic and social impact of photography, and to place this into the context of the sweeping changes in the nineteenth century in demographics, science and technology, thought and culture. While partly a history of making, it is also a history of looking. For if photography was a mirror to the world, how then might the world have fashioned itself against its reflected image?

The narrative which is to be explored here, the precursor to the rise of photography as an apparatus of surveillance (used for documents, evidence and records), is the story of the growth of social and celebrity portraiture amongst the newly emergent urban middle classes. The very first announce-ment of photography in 1839 awakened a desire to apply this new medium to the portrait. The essential fascination with the human face, which is innate, was tempered by a preceding history of portraiture whose legacy was a mature

fig.15 Roger Fenton
Photographic Van, Sparling on the Box, 1854
Salted paper print from wet collodion negative
© The J. Paul Getty Museum, Los Angeles
Courtesy of Michael Wilson Photographic Collection

In 1854 Roger Fenton was commissioned by the art dealers Thomas Agnew & Sons to photograph the principal military figures of the Crimean War. His use of the wet collodion process necessitated the proximity of some form of portable darkroom. The photographic van provided the solution and would have been tightly packed with heavy equipment and supplies. Because of the bulk and difficulty in replenishing supplies, he would have taken great care with each exposure and would have used his materials sparingly. The figure seated on the box is Sparling, one of Fenton's two assistants.

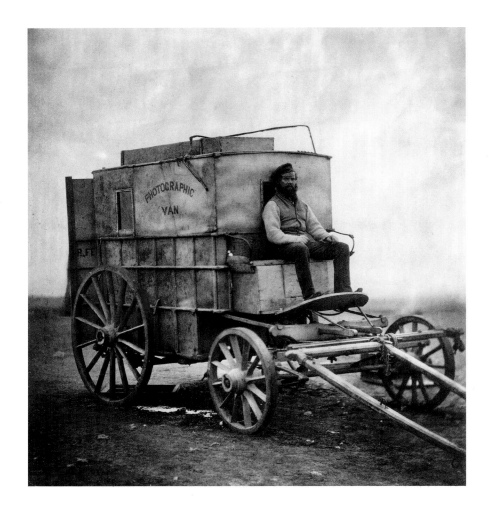

genre, both commercially viable and socially useful. It also occurred at a time when mill owners and industrialists were widely perceived to have created wealth and status through their entrepreneurial exploitation of new technologies. New money was around and new money was to be made. Photography offered the double promise, of an exploitable technology in its own right and of a new means of making and distributing images of the face for a group of people acutely conscious of social status and driven by the aspiration of self-advancement. What emerges is a causal link between the developing market for portrait photography and the quick-fire sequence of refinements in optics, mechanics and chemistry that occurred with increasing rapidity in photography's first fifty years.

The accelerator for so many of these developments was the public appetite for images of the most celebrated and noteworthy individuals of the day.

Their increasing visibility through photography aligned the commodification
of personalities to the fashion for ordinary members of the middle classes to
appear before the camera. Fame and photography were drawn together in the
mid-nineteenth century by an almost innate magnetic impulse. Their fusion,
particularly in the 1850s and 1860s, helped create an explosion in the cult of
celebrity that continues to this day as one of our most abiding cultural
passions. What is increasingly apparent, as we look back across this period
of photographic history, is how the terms of engagement and the defining
characteristics of modern celebrity were painstakingly mapped out and the
essential relationships, between the celebrities, the makers and mediators of
their images and the public at large were first established. Of particular
interest are those public figures whose rush-hour of fame coincided with
the advent of this new technology; personalities such as Thomas Carlyle
(1795–1881), Florence Nightingale (1820–1910), Charles Dickens and the
ubiquitous Alfred Lord Tennyson (1809–92). For this was the first generation
to experience the pressures of being mediated personalities.

 The fate of Tennyson provides a valuable cautionary tale for the tensions
between visibility and privacy. As poet laureate of the high Victorian age and
author of *The Charge of the Light Brigade,* (1854) *Maud: a Melodrama* (1855)
and *The Idylls of the King* (1859), he enjoyed ever increasing popularity over
the long span of his life. The high point of his fame coincided with the
spectacular rise of photography and he was compelled into the studios of
men such as James Mudd (active 1854–70) in 1857, W. Jeffrey in 1862, and
Herbert Rose Barraud (1845–96) in 1888, as well as being photographed at
home by O.G. Rejlander (1813–75) in 1862 and cajoled into the greenhouse
of his neighbour, Julia Margaret Cameron in 1862. The game was up for this
notoriously private man who was renown for concealing his identity and
withdrawing to the Isle of Wight hideaway of Freshwater Bay. The public
intrusion into his life triggered by the mass circulation of his image was
compounded by easier access to his island retreat: the steam ferry and the
railway put the island within reach of day trippers from London who spied
upon his private domain. He was stopped in the street by people he had never
met and who, recognising his face from his published photograph, could not
resist the instinctive desire to match the flesh and blood countenance against
the mediated image. He began to see 'cockney' autograph hunters in innocent
passers-by and to regret bitterly the public invasion of his privacy (Thorn,1992,
p.333). The positive side of this increased visibility were the phenomenal rise
in sales of his poetry and ever fatter royalty payments.

 While Tennyson's generation were coming to terms with the demands
of visible celebrity, of being faces as well as names, they were also the last to
have known a time before photography. Charles Dickens, who evidently
appreciated the lure of popular acclaim, linked death and photography in the

opening page of *Great Expectations* (1860–1). The narrator, Pip, states that, 'As I never saw my father or my mother, and never saw any likeness of either of them (for their days were long before the days of photographs), my first fancies regarding what they were like, were unreasonably derived from their tombstones.'

In the early nineteenth century, in that time before photography, to have your portrait made, even as a painting in miniature or profile, would have been a costly luxury. Although the craft of silhouette cutting, which had become increasingly fashionable in the eighteenth century, had made at least some form of likeness accessible to the wider populace, it was the detailed likeness, achieved only by the most skilled artist, that was the object of desire. To be 'done in oils' conferred status as well as providing an opportunity for contemporary celebration. It also ensured that the memory of your countenance could be preserved for veneration by future generations. This desire for immortality was underscored by the recognition that the art of portraiture, in Britain at least, was the result of royal patronage. The first true flowering occurred during the reign of Henry VIII (reigned 1509–47), when Sir Thomas Moore (1478–1535) commissioned Hans Holbein the Younger (1497–1543) and the King himself attracted some of the most talented European artists (Hayes, 1991, p.12). In the dynastic courts of Europe portraits served a number of purposes: as cyphers of gossip and intrigue, as advertisements for potential marriage partners or as favours to chosen courtiers and statesmen. As the popularity of portraiture spread throughout the nobility, it developed a more prosaic function as an ostentatious expression of wealth. From the seventeenth century onwards, houses, horses and hounds were paraded across the canvas to enrich the central figures of the portrait.

By the eighteenth century the market for portraiture had extended beyond the aristocracy to encompass the new, monied middle classes: lawyers, clergy, and merchants. Members of this emergent class had sought to fashion their social status through cooperation and collusion. A plethora of professional institutions came into being, which elevated the standing of individual members through the advancement of the collective identity. Artists sought to both emulate this trend and to offer themselves to the sensibilities and purses of the evolving market. In 1760, under the guidance of Joshua Reynolds (1725–92), they formed the Incorporated Society of Artists of Great Britain which evolved into the Royal Academy in 1768. Their annual programme of public exhibitions, modelled on the Paris Salon, effectively replaced the Court as the centre of patronage.

While the Academy exhibitions, in which portraiture predominated, attracted large crowds, these were drawn exclusively from the upper echelons of London society. Viewers were there not just as admirers but as potential clients, and the paintings they commissioned were destined to be hung behind

the closed doors of palaces, private estates and professional institutions. Ownership and access to these grand painted portraits, even allowing for the art of the copyist, were limited to the select few. As such they do not easily conform to our modern notion of selling celebrity. For fame to flourish, the image needs to be placed in the public domain either through display or proliferation, and the antecedent of our current notion of fame has its origins in the society and culture of Classical Greece and Rome. For it is in these ancient civilisations that we find the first evidence of a culturally created pantheon of historical and contemporary heroes: individuals singled out for public veneration and celebrated for their political, intellectual and sporting achievements. Their sculpted busts, with their names chiselled into the base, were hoisted onto pedestals and placed on public display. But there is also evidence of portraits being painted, minted as coins and medallions and collected, with brief acclamatory descriptions or testimonia, into encyclopaedic biographies.

Portraits and biographies

The first record of an illustrated biographical encyclopaedia is that of the Roman scholar and public librarian Marcus Terentius Varro (116–27 BC), who is believed to have compiled a compendium of 700 painted portraits of celebrated Romans, each accompanied by a distilled biography (Baldwin and Keller, 1999, pp.16). The linking of portraiture and biography, with the attendant labelling of a likeness and the anchorage of the subject's achievements by a laudatory account of their noteworthy deeds, is a particularly potent instrument for fame. It elevates the esteem of individuals by placing them in the context of an elite grouping of the most highly revered.

The trend for collecting assemblages of illustrated portrait biographies took root in Britain in the eighteenth century on the back of the flourishing trade in mezzotint engravings. In common with the gentlemanly pursuit of collecting medals, the production of engravings enabled ever-widening circles to own likenesses of their preferred celebrities. This satisfied an instinctive urge within this growing market and provided a critical catalyst to the evolution of the cult of fame: a tactile memento and the promise of both having and holding their chosen hero.

In 1769 the Reverend James Granger (1723–76), a cleric, biographer and print collector, published *A Biographical History of England*. It provided a system of hierarchically ordered short biographies of significant historical figures together with an inventory of all known engraved portraits and the works in which they had then been published. Collectors pasted their engravings together with the corresponding pages cut from Granger to form their own

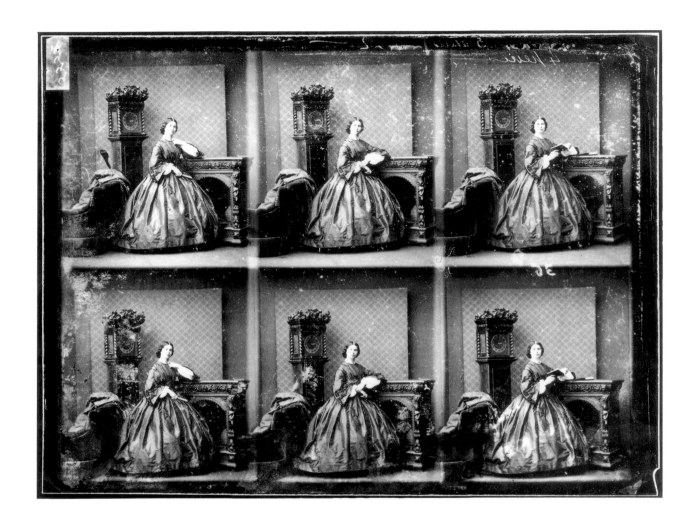

fig.16 Camille Silvy
Miss B. Brook Hunt, 1861
Modern print of uncut sheet of *cartes de visite* from wet collodion negative
National Portrait Gallery (x6400)

customised 'Grangerised' collections. The impulse was to add to collections, using Granger as guide for ordering new engravings from print dealers. As a direct consequence, the average price for an English portrait engraving rose five fold (Prescott, 1985, pp.17). Horace Walpole (1717–97), to whom Granger had dedicated his book, complained that 'since the publication of a catalogue scarce heads not worth three pence would sell for five guineas' (Pointon, 1993, p.58).

The full, rambling but revealing title of Granger's work is *A Biographical History of England, from Egbert the Great to the Revolution: consisting of Characters disposed in different classes, and adapted to a methodical Catalogue of Engraved British Heads intended as an Essay towards reducing our Biography to System, and a Help to the knowledge of Portraits. With a preface showing the utility of a Collection of Engraved Portraits to supply the Defect, and answer the various purposes of Medals.* The distinguishing feature of the Grangerised system, of a 'methodical Catalogue' that reduced 'Biography to System', was the imposition of a strictly delineated hierarchical ranking of social groups into twelve descending orders of class:

CLASS I Kings, Queens, Princes, Princesses, &c. Of the Royal Family.

CLASS II Great Officers of the State & of the Household.

CLASS III Peers, ranked according to their precedence & such commoners as have their Titles of Peerage; namely, Sons of Dukes &c and Irish Nobility.

CLASS IV Archbishops and Bishops, Dignitaries of the Church, & inferior clergymen. To this class are subjoined the Nonconforming Divines and Priests of the Church of Rome.

CLASS V Commoners who have borne great Employments: namely Secretaries of State, Privy-Counsellors, Ambassadors, and such Members of the House of Commons as do not fall under other classes.

CLASS VI Men of the Robe; including Chancellors, Judges, and all lawyers.

CLASS VII Men of the Sword: all officers of the Army and Navy.

CLASS VIII Sons of the Peers without Titles, Baronets, Knights, ordinary Gentlemen, and those who have enjoyed inferior civil Employments.

CLASS IX Physicians, Poets, and other ingenious Persons, who have distinguished themselves by their Writings.

CLASS X Painters, Artificers, mechanics, and all of inferior Professions, not included in the other Classes.

CLASS XI Ladies and others, of the Female Sex, according to their Rank, &c.

CLASS XII Persons of both Sexes, chiefly of the lowest Order of the People, remarkable from only one Circumstance in their Lives; namely such as lived to a great Age, deformed Persons, Convicts, &c.

(Granger, 1769)

Marcia Pointon in her book on portraiture and social formation in eighteenth-century England, *Hanging the Head* (1993), further notes:

If the system and the collecting practice serve to separate head from body, indeed privilege the head over and above the body, that symbolic structure must be understood in its relation to a hierarchical process in which society's disparate parts are inscribed in a hegemonic order. Underlying such a structure in the eighteenth century is a long tradition originating in the medieval bio-political schema of the corpus Christianum. (Pointon, 1993, p.56)

Granger's system of biography is of enduring significance for understanding the enthusiasm and growth of portrait photography in the nineteenth century. Firstly, the sweeping changes brought on by political and industrial revolution in Europe created a society in constant need of revising and reordering its hegemonic order. The shock of Darwin's evolutionary theory contained in *On the Origin of Species by Means of Natural Selection* (1859) contributed no less a jolt to the body politic and shook creationist theory to its very foundations. Photography provided the ideal apparatus for both inventory and classification, a startling new means of visualising the replenishment and reshuffling of the social pack.

Secondly, the success of Granger spawned an entirely new genre of publishing, and the introduction of steel-plate engraving in the 1810s opened the gateways for an unstoppable flow of publications. Single complete volumes and pre-packaged part works of biographies and engravings were produced in large print runs and at relatively low cost. For the first time, contemporary and recently deceased heroes eclipsed figures from history in titles such as William Jerden's *National Gallery of Illustrious and Eminent Personages of the Nineteenth Century: with Memoirs* (1830–3) and Charles Knight's *The Gallery of Portraits: with Memoirs* (1833–7). Of course engravings were not limited to portraiture, but applied in equal abundance to illustrations of topography, architecture, science and nature. Anything, in fact, that required precise and recognisable detail in an age when the dominant impulse was to audit and order both the social and the natural worlds. Here then was a potential market ripened for a new media to exploit, establish itself and evolve its own distinctive codes, style and rhetoric.

In 1839 the French Government announced that the photographic process pioneered by Louis Daguerre (1787–1851) and by Niecéphore Niépce (1765–1833) would be freely available, unfettered by licences and patents. This apparently grand and magnanimous gesture, for which Daguerre and the surviving family of Niépce would receive a pension for life, was calculated partly to thwart the English counter-claims of William Fox Talbot (1800–77) and partly in recognition of the complexity of asserting enforceable patent rights across Europe and America. The Industrial Revolution in Britain had inspired a local respect for the power of invention, and patent laws were more clearly defined there. Daguerre had pre-empted the Paris announcement by

privately negotiating a separate patent in Britain, finally ratified in 1841. Fox Talbot meanwhile became increasingly embroiled in legal wrangles that led one detractor to proclaim that he was trying to secure for himself, 'a complete monopoly of the sunshine' (Arnold, 1977, p.175).

What distinguished the announcements of the first two competing systems of photography in 1839, the French daguerreotype process and Fox Talbot's method of paper-based negative and positive photography, was the tension between precision and multiplication. The daguerreotype produced a reversed and unique image that had been exposed in the camera onto a copper plate with a highly polished silver surface. The plate was sensitised by iodine fumes and then, after exposure in the camera, developed by fuming over heated mercury vapour. Fox Talbot's photogenic drawings were, by comparison, cruder affairs: paper treated with alternate washes of salt and silver and exposed while moist in a *camera obscura*. While the daguerreotype produced an infinitely sharper and more detailed image, the 'talbotype' had arguably the greater potential, establishing the principle of a negative and positive that would be the foundation of modern photography.

That two similar but differing solutions should be arrived at, apparently independently, was no accident. The invention of photography was not the product of a blinding flash of inspirational light, nor was it a chance discovery that would, overnight, present the world with a hitherto unimagined wonder. Rather, photography was one of those great technological developments of the machine age of industrialisation that has a pre-history, a delicious period of suspense between imagining the concept and awakening to the dream. For at least a small handful of scientifically rooted visionaries it had been predicted and anticipated. Writing in *The Pencil of Nature* (1844–6), Fox Talbot recalled his frustrations at the inadequacies of the sketches he practised with the *camera lucida* during his honeymoon stay at Lake Como in 1833:

> And this led me to reflect on the inimitable beauty of the pictures of Nature's painting which the glass lens of the camera throws upon the paper in focus – fairy pictures, creations of a moment, and destined as rapidly to fade away. It was during these thoughts that the idea occurred to me … how charming it would be if it were possible to cause these natural images to imprint themselves durably, and remain fixed upon the paper (Fox Talbot, 1844–6).

If photography was to be realised it had to be teased away through a process of deduction and experiment; in short it was a problem to be solved.

By the December of that decisive year, 1839, Fox Talbot's romantic notions of 'charming' 'fairy pictures', had hardened into more commercial concerns. In writing to Sir John Herschel (1792–1871), the astronomer and author of the term photography, he reiterated his view of the need for the multiplication of the image:

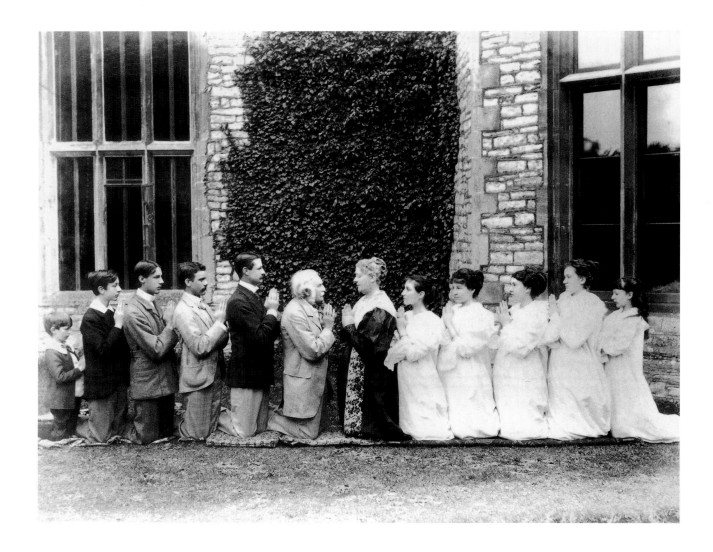

fig.17 Graystone Bird
*Sir Richard Strachey and his Family, c.*1893
Albumen print on the photographer's
printed mount
National Portrait Gallery (x13122)

The large, self-contained nuclear family became the established norm for aspirant middle-class Victorians. Sir Richard Strachey was that most nineteenth-century of figures, a Colonial administrator, soldier, engineer and botanist. The mock piety of the picture evokes the spirit of family parlour games. Of the sons, James Beaumont (far left) was to make his name as a psychoanalyst, and Giles Lytton (next right) was to debunk his father's generation with the publication of *Eminent Victorians* (1918).

I am convinced we are only on the threshold of what may be done. Although the perfection of the French method of photography cannot be surpassed in some respects, yet in others the English is decidedly superior. For instance in the capability of multiplication of copies & therefore of publishing a work with photographic plates.

This belief in the capability of multiplication continued to be at the core of Talbot's photographic investigations long after the first spat over primacy of photographic invention had died away; firstly, with the calotype process proposed in 1840 and later, through his research into secondary print processes and photo etching which continued until his death in 1876.

While the early photographic processes emanating from Britain and France could not encroach immediately upon the business of the engraver, they posed a readily identifiable latent threat. The threat was articulated as early as December 1839 in the celebrated cartoon by Theodore Maurisset, *Daguerreotypomania*, which lampoons the first rush of photographic enthusiasm in France. It depicts a snaking crowd arriving from a distant steam train, swarming into the streets of Paris to buy up and try out the new daguerreotype process. On their way the crowd passes by newly erected gallows with the first few bodies of suicidal engravers swinging beneath a sign that reads, 'Death to

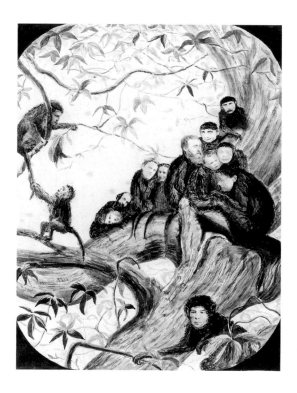

fig.18 Kate E. Gough
Untitled Page from a Photograph Album, c.1870
Trimmed *carte de visite* albumen prints and watercolour
© The Board of Trustees of the V & A Museum

This page is from an album made up by Kate Gough, constructed during her teenage years. The page is typical of her style of creating waspish caricatures and naive surrealist juxtapositions from cut and pasted, spare *cartes de visite*. The faces of her relatives are pasted onto the bodies of a family of apes, in clear and mocking reference to the publication of Charles Darwin's *Origin of Species* (1859).

the aquatint'. In the best traditions of caricature, the image was a distortion of the reality, but the enthusiastic reception of photography was real enough. One contemporary account of the publication of the details of the new process on 19 August 1839 recorded that, 'a few days later, you could see in all the squares of Paris three-legged dark boxes planted in front of churches and palaces. All the physicists, chemists and learned men of the capital were polishing silvered plates, and even the better-class grocers found it impossible to deny themselves the pleasure of sacrificing some of their means on the altar of progress, evaporating it in iodine and consuming it in mercury vapour.' (Gernsheim, 1982, p. 45).

While the innovation generated great excitement, it was as yet incapable of mimicking engraving as a distributable medium. Exposure times were, by subsequent standards, painfully slow, amounting to between five and thirty minutes depending on the brightness of the light. While this problem was surmountable, and within two years exposure times would be brought down through the one-minute barrier to around fifteen to twenty-five seconds, there was one limitation that was clearly not: each daguerreotype image was unique. The quixotic, polished, mirrored plate, which needed to be tilted and teased to the right angle, flickering between positive and negative, to reveal the exquisitely detailed image, was the same plate that had been exposed in the camera. It was possible to re-photograph the plates, but there was a resultant loss of image quality and the process was expensive. The best that could be done was to set up several cameras at the same time, with the Swiss daguerreotypist, Johann Baptist Isenring (1796–1860), attempting a pyramid of six (Frizot, 1998, p. 40).

As the process became established, the convention emerged of setting the plates behind gilt-trimmed protective glass set in velvet-lined leather cases held together by a gold clasp. Even in the present age of near-perfect facsimile, a reproduction of a daguerreotype loses something of the magic of the original. There is a very real tactile pleasure in handling a daguerreotype case, opening it up to scrutinise it through a squinted eye then re-clasping it shut. It fits snugly into the hand and has weight and substance. The design and technology preclude any real usefulness as a public object, rather it has the inherent qualities of a personal and private keep-sake. And this was how it was used, an object to be kept amongst personal effects, to be brought out and shown, handed around and then put away. The 1840s audience must have taken great delight in encountering their first photographic images in such a way. 'A mirror with a memory' was how one commentator described it. And memory implies mortality. This was an age of persistently high infant death rate and a time when even wealth could not provide immunity from disease and epidemic. The play between negative and positive, the daguerreotype's characteristic of appearing and disappearing, its 'shining

sorcery', appealed to the prevailing fascination with death and the taste for spiritualism and gothic horror. Allan Trachtenberg in his essay 'Reflections on the Daguerrean Mystique' quotes from a periodical that appeared in both France and America in 1853: 'There is something about the daguerreotype that bespeaks a hand not of this world. Surely to punish us for penetrating her mysteries, Nature touches us with the shadowy hand of death in revealing them!'

However, the daguerreotype had within it the seeds of its own demise, and the impulse towards photographic reproduction meant that it would only ever be a pleasurable diversion from the road to the mass-mediated image. Its eternally redeeming feature was the exactness of its detail. The eminent scientist, Alexander von Humboldt, on seeing Daguerre's *View of the Boulevard du Temple, Paris, c.*1839, was struck by the power of the image to 'represent' everything. He took particular delight in noting that 'One could see in the image that in one skylight – and what a trifle – a pane had been broken, and mended using gummed paper.' (Frizot, 1998, p.28.) This ability of the camera to capture apparently accidental, irrelevant or even profane details that prick the imagination of the viewer is a phenomenon which the semiologist Roland Barthes (1915–80) was to term 'a photograph's punctum'. That images should be 'speckled with these sensitive points' lingers as the abiding fascination of photography and ensured that the legacy of the daguerreotype was the setting of a benchmark for precise detailing. Its other great achievement was to establish the commercial possibilities of photography, particularly in the business of portraiture.

Despite the opinion of François Arago (1786–1853), a distinguished scientist and the champion of Daguerre's work, that 'one is little disposed to admit that the instrument will ever serve to make portraits' (Gernsheim, 1982, p.84), portraiture became an objective and, once exposure times had been reduced, an attainable goal. It is estimated that from its first inception in 1839 through to its final demise in the late 1850s, 90 percent of all daguerreotypes were portraits. The evidence provided by photography and the possibility of portraiture proved grist to the entrepreneurial mill.

The business of the studio

In the late 1830s two American partners in a firm manufacturing optical instruments, Alexander Wolcott (1804–44) and John Johnson, set about developing a camera with a concave mirror that intensified the light focussed on the plate, thus radically reducing exposure times. Once their innovation had been refined they promptly opened the world's first portrait studio in New York in March 1840. Others quickly followed in the industrialised cities of Europe and America, and the mania for the daguerreotype was no longer

fig.19 Nadar
Sir George Scharf, 1867
Albumen *carte de visite*
National Portrait Gallery
(AX29987)

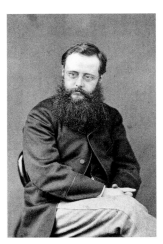

fig.20 Cundall, Downes & Co.
Wilkie Collins, c.1860
Albumen *carte de visite*
National Portrait Gallery
(AX41359)

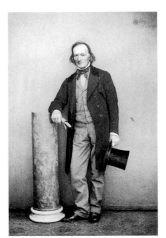

fig.21 Maull & Polybank
Richard Owen, c.1861
Albumen *carte de visite*
National Portrait Gallery
(AX29679)

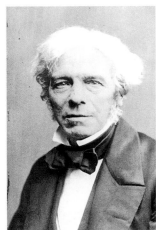

fig.22 John Watkins
Michael Faraday, c.1861
Albumen *carte de visite*
National Portrait Gallery
(AX16267)

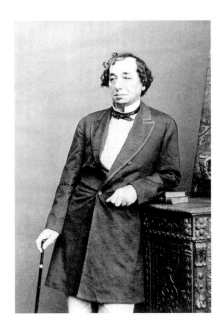

fig.23 John Jabez Edwin Mayall
Benjamin Disraeli, c.1861
Albumen *carte de visite*
National Portrait Gallery (x5061)

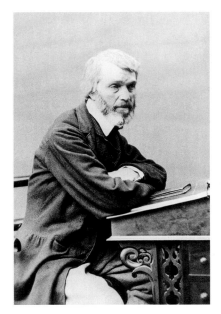

fig.24 John and Charles Watkins
Thomas Carlyle, c.1861
Albumen *carte de visite*
National Portrait Gallery (x5086)

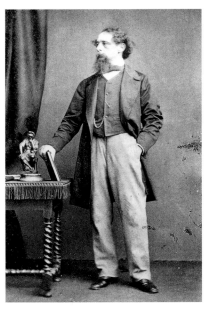

fig.25 John and Charles Watkins
Charles Dickens, 1861
Albumen *carte de visite*
National Portrait Gallery (P26A.113)

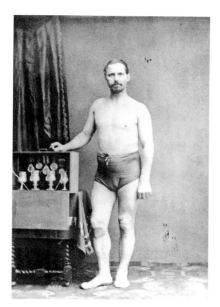

fig.26 Unknown photographer
Unidentified Swimmer, c. 1860
Albumen *carte de visite*
National Portrait Gallery (AX47088)

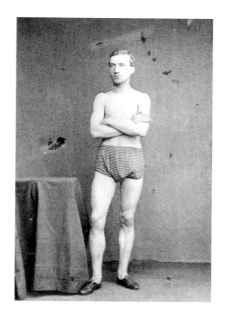

fig.27 Unknown photographer
Jones, Athlete, c. 1860
Albumen *carte de visite*
National Portrait Gallery (AX47087)

fig.28 Published by George Newbold
Hartley, Runner, c. 1860
Albumen *carte de visite*
National Portrait Gallery (AX47091)

fig.29 Published by George Newbold
Young Shaw, Athlete, c. 1860
Albumen *carte de visite*
National Portrait Gallery (AX47097)

fig.30 Mayer Brothers
Unknown Athlete, c. 1860
Albumen *carte de visite*
National Portrait Gallery (AX47095)

These *cartes de visite* are from the personal collection of the first Director of the National Portrait Gallery, Sir George Scharf. They represent a lilliputian private museum and mirror his public role of assembling a pantheon of historical celebrities. While some of the figures were admired from afar, others he would have known and mixed with within his social world.

Before the use of *bertillonage*, photographic evidence to identify criminals and their victims was assembled from many sources, including *cartes de visite*. This alternative use suggests the wider social context in which the subjects of the photographs lived.

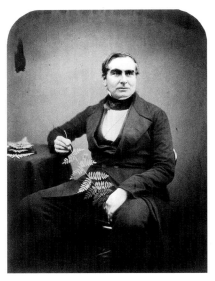

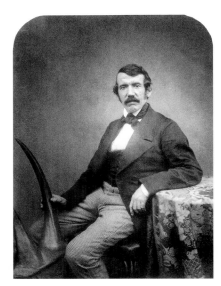

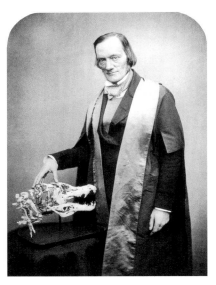

fig.31 Maull & Polybank
Thomas Corbyn Janson, 1855
Albumen print
National Portrait Gallery (P120[46])

fig.32 Maull & Polybank
David Livingstone, 1855
Albumen print
National Portrait Gallery (AX7279)

fig.33 Maull & Polybank
Sir Richard Owen, 1855
Albumen print
National Portrait Gallery (P106[15])

These three images are taken from Maull & Polybank's *Photographic Portraits of Living Celebrities*, one of the earliest examples of a published photographic portrait series. Sitters were invited to bring a defining prop to their portrait session. Not all complied but of those that did, Michael Faraday chose to hold a magnet, David Livingstone sat astride a rhinoceros horn, Thomas Janson delicately dangled a fern and Sir Richard Owen opted to hold down the advancing jaws of a reptile's skull.

in the doing but in the being done – although it should be remembered that Samuel Morse's (1791–1872) and John Draper's (1811–82) early New York studio of 1840 attracted more would-be entrepreneurs wishing to be trained than sitters paying for their portraits. Initially at least, the experience was expensive, so available only to the monied middle classes. Nonetheless it was cheaper than the painted portrait and had the added cachet of being thoroughly modern, an instant means of not only conferring status but of emphasising that status in the radical new order of this capitalist, urbanised world. At the elite end of the market, studios evolved as increasingly elaborate stage sets with fine furniture and rich drapery, borrowing liberally from the traditions of the painted portrait and providing domestic props that implied affluence and underlined the client's status as an independently prosperous and socially significant individual. The daguerreotype salons of America, in particular, established a trend for creating a sense of special occasion, showcasing the very latest in interior design and decoration; to visit them was an experience in itself. Mathew Brady's studio on New York's Broadway was greeted with a lavish description when it opened in 1853:

> At the door hangs a display of specimens which are well arranged in rich rosewood and gilt show cases. The Reception Rooms are up two flights of stairs, and entered through folding doors, glazed with the choicest figured cut glass. The floors are carpeted with superior velvet tapestry, highly coloured and of a large

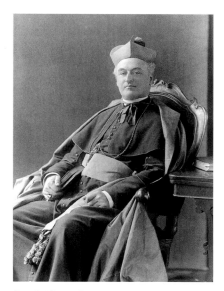

fig.34 Alexander Bassano
Ellen Terry, Actress
Modern print from negative
National Portrait Gallery (x96389)

fig.35 Alexander Bassano
Lord Charles Beresford
Modern print from negative
National Portrait Gallery (x96200)

fig.36 Alexander Bassano
Cardinal Vaughan
Modern print from negative
National Portrait Gallery (x96601)

and appropriate pattern. The walls are covered with satin and gold paper. The ceiling frescoed, and in the centre is suspended a six-light gilt and enamelled chandelier, with prismatic drops that throw their enlivening colours in the most costly needle worked lace curtains . . . The harmony is not the least disturbed by the superb rosewood furniture – tête-à-têtes, reception and easy chairs, and marble-top tables, all of which are multiplied by mirrors from ceiling to floor (Panzer, 1997, pp. 43–4).

The sitters were frequently depicted holding or reading a book, providing a practical solution to the problem of how to sit still and occupy their hands while economically alluding to their culture and education. Heads were held firm by iron clamps supported on stands. With the emergent photographic industry came the attendant industries of the camera, chemical suppliers and manufacturers of props, clamps and supports. The slightly aloof raised chin and quizzical stare into the mid-distance that characterise portraits of the period are not only a result of the need to be held steady during the slow exposure but also a reflection of the enduring beliefs in character and morality. Reading the face and measuring the head had become widespread practices through the popularity of the pseudo-sciences of physiognomy and phrenology. Various systems of phrenology had been advanced in the early nineteenth century, proposing the theory that moral and intellectual faculties could be located in different parts of the brain. Not only could the overall size and shape of the

skull be measured, but bumps and hollows on different parts of the head
could be calibrated to signify strengths and deficiencies of character. The
craze developed for feeling heads in order to 'read the bumps'. One leading
American advocate, O. S. Fowler, believed that a phrenologist could
'pronounce decisively whether a man is a liar, a thief or a murderer' by the
skilled measurement of his skull (Sobieszek, 2000, p.100).

Physiognomics had enjoyed a long and ancient history before it had
been revitalised in the nineteenth century through the voluminous writings
of Johann Casper Lavater (1741–1801). Put simply, the face, particularly
when viewed in its static and fixed state, was seen to frame a series of
outward signs, mapped across the features, that could be read as evidence
of the inner soul. A high brow and a prominent chin were commonly
understood to be indicators of a higher intellect. Photographers and clients
alike, concerned as they were with the business of portraiture, would have
approached sittings with a keen awareness of the popular notion of
Lavater's classifications. The sitters could be persuaded to contort in order
to present their most desirable physiognomic traits to the photographer,
thus ensuring that their portrait would act as evidence to their good character.

Inevitably the grander studios attracted the greater attention and the
surviving testimonies in journals and periodicals of the day have perhaps
coloured our view of the real business of photography. The true demographics
of this emergent industry can be seen more clearly in the Paris Chambre de
Commerce's audit of Parisian industries in 1847–8. It surveyed fifty-six
daguerreotype businesses and recorded that, of these, thirty-eight were single-
operator affairs, thirteen employed just one assistant, four had between two
and ten employees and one had a workforce of forty-eight (McCauley, 1994,
pp.48). While the larger establishments dominated the market and attracted
the lion's share of the business, the emergence of the one- or two-person
operation served to undercut the cost of the product and to percolate access to
portraiture down the social and economic ladder. Itinerant photographers,
touring outlying towns and regions, contributed to the geographic spread of
photography.

In Britain the development of the market for the daguerreotype followed
a different form. Its growth was frustrated by the restrictions of Daguerre's
patent which had been secured by Richard Beard (1802–85), a former
Bermondsey coal merchant. Beard had the power to issue licences for the
process, so effectively controlling any competition. The only exception was
Antoine Claudet, who had secured a separate licence to 'use a limited portion
of the apparatus in consideration of the sum of £200'. Claudet would, in time,
eclipse Beard with innovations such as the stereoscopic daguerreotype. On
23 March 1841, with an imported Wolcott camera, Beard opened the first
European commercial photographic studio on the top floor of the Polytechnic

Institute on London's Regent Street. In the first three months of its existence, Beard claimed to have grossed almost £3000 (Gernsheim, 1982, pp.125–6). A popular contemporary woodcut by George Cruikshank (1792–1878) illustrates S. L. Blanchard's doggerel verse *The New School of Portrait Painting* (1842):

> Like the crowds who repair
> To old Cavendish Square,
> And mount up a mile and quarter of stair
> In procession that beggars the Lord Mayor's show!
> And all are on tiptoe, the high and the low,
> To sit in that glass covered blue studio;

The engraving gives us something of the flavour of the studio. The sitters were placed on a high-backed chair with their heads fixed by 'a kind of neck iron'. This was set on a raised dais that could be turned throughout the day to follow the arc of the sun. The Wolcott cameras, for which Beard had negotiated separate rights, were on a high ledge that could also be moved along a rail. Prospective clients can be seen in the engraving examining samples through a magnifying glass, with the operator perched on a stepladder, pocket-watch in hand, counting the exposure time. To one side, an assistant is busily buffing up the silvered copper plate to a high shine for the next exposure. The circular glass roof was tinted blue in the erroneous belief that it could produce a better quality of light and shorten exposure times. To have made the long climb to this roof-top eyrie with its strange chemical smells, clock-counting operators and restraining chairs, the entire scene being cast in what early visitors described as 'a snap-dragon blue', must have heightened the senses and quickened the pulse. For all our notions of a new technology in a machine age, the experience of being photographed must have inspired in the first-time visitor something of the supernatural and the uncanny. Beard's quickly amassed fortune – he was reputed to have made between £25,000 and £35,000 in his second year of business – proved equally quixotic, vanishing in a welter of legal actions in defence of his patents. By the autumn of 1849 he had filed for bankruptcy.

The age of collodion

The demise of the daguerreotype began soon after with the publication in *The Chemist* (1851) of Frederick Scott Archer's (1813–57) wet collodion process. By the late 1850s the daguerreotype had all but gone, its most successful market, and the last to fall, being in America. In New York the number of studios rose from sixteen in 1846 to fifty-nine in 1850 to over 100 in 1853. Over 10,000

fig.37 Sampson Low, Marston,
Searle & Rivington (Publishers)
*Men of Mark: A Gallery of
Contemporary Portraits*, 1880
National Portrait Gallery (Album 81)

fig.38
Swan Sonnenschein & Co. (Publishers)
Our Celebrities, Part-work no.15, 1889
Private collection

operators were at work across the nation generating some three million daguerreotypes a year. It had even spawned its own town, Daguerreville on the banks of the Hudson, built around a factory manufacturing daguerreotype supplies (Gernsheim, 1982, p.119). In its wake it left, as though caught in aspic, the first preserved inventory of a nation's aspirational middle class. The precise and unique portraits must have appealed to the private citizen and the puritan spirit of individualism in a nation as yet untroubled by civil war. And yet, as Allan Trachtenberg points out, it is 'a limited social panorama' that 'under-represents whole sections of the nation: the poor, the enslaved, the incarcerated, the unskilled, the excluded and expropriated'. In commodifying social identity the daguerreotype had evolved a new grammar of character and self-advertisement that would become the template for future processes. The excluded and marginalised would be brought back into the social ordering through the camera, not as idealised images but as objects subjected to new forms of visual rhetoric, labelled for coercion and control.

While the daguerreotype was an essentially private object it could still be exploited as an instrument of celebrity. The account of the lavish appointment of Brady's Broadway business concludes by itemising the images of the famous displayed in the studio: 'Suspended on the walls we find the Daguerreotypes of Presidents, Generals, Kings, Queens, Noblemen – and more nobler men – men and women of all nations and professions.' (Panzer, 1997, pp.43–4.) Brady had honed in on the famous from the very beginning, targeting Washington's politically illustrious who had gathered for the approaching inauguration of President Zachary Taylor (1784–1850) in spring 1848. A newspaper account publicised his intention of obtaining portraits of 'all the distinguished men who may be present', with the object of forming 'a gallery which shall eventually contain life-like portraits of every distinguished American now living'. Similarly, Edward Anthony (1818–88) had worked in Washington between 1842 and 1844, systematically making daguerreotypes of every member of Congress. In 1843 he exhibited them in his National Miniature Gallery, located amongst the first leading studios on New York's Broadway. The entrepreneur John Plumbe (1811–57) compiled a collection of celebrity portraits and invented a new lithographic process to translate his daguerreotypes into print, publishing his *Plumbotype National Gallery* in 1846. Brady followed suit by collaborating with journalist Charles Edward Lester to publish the *Gallery of Illustrious Americans*, a series of twenty-four lithographs based on Brady's daguerreotypes published in 1850. The series followed the established custom for marketing portrait engravings by offering each work accompanied by a biography and available on a subscription basis. Lester claimed that it was the daguerreotype that distinguished this work of modern times by bringing new exacting standards to bear that invested the portraits with a 'vital energy and living truth'.

In America, at least, a small cadre of photographers and publishers were
straining at the bit to find new ways of amalgamating celebrity and photography
as a potent commercial mix. The inability to multiply and distribute the image
was proving the major limitation. The wet collodion process was the first major
step towards a solution, and its announcement in 1851 would set in motion a
revolution in photography that reverberated throughout the remainder of the
century. The first phase of photography's history was coming to a close and it had
aroused an appetite for the new media that inspired inventiveness, conjecture
and speculation. The relatively rapid sequential progression of overlapping
phases of technical development that occurred in the medium's first fifty years
was indicative of its vitality and awakening spirit. Each phase imposed its own
aesthetic, cultural and economic order and each was superseded because its
initial success awakened a rapidly thwarted ambition. From the moment
photography was announced, it gained a momentum all of its own.

Here was a new process that combined something of the precision of the
daguerreotype with Talbot's principle of the negative and positive. It utilised a
glass plate that, after exposure in the camera, could be used either as a negative
from which to make paper-based prints or, by bleaching and backing with
black, as a one-off cheaper alternative to the daguerreotype. A year earlier
L. D. Blanquart-Evrard (1802–72) had introduced an alternative to salted
paper: the albumen-coated print. Thin paper, coated with a layer of egg
white, was sensitised with silver nitrate solution. Prints had a glossy surface
which could be enhanced by gold toning and produced a broader and more
subtly delineated range of tones. The glass was coated with collodion and
potassium iodine and sensitised with a second coating of silver nitrate, applied
moments before the exposure was made. The plate was then placed in the
camera while still wet and the picture taken. The only limitation in the
process was that preparation and development of the plate had to be made
within moments of the exposure, necessitating some form of darkroom
within reach of the camera. It would make location work difficult, but was
perfect for studio-based portraiture. The glass negative substantially reduced
exposure times and, compared to the calotype, it produced a sharper, more
detailed image. Its inventor, Frederick Scott Archer had been introduced to
calotype photography by his doctor, Hugh Diamond (1809–86), then in general
practice, in the years before his appointment as Superintendent of the Surrey
Asylum. The limitations of Fox Talbot's process had inspired Archer to
resolve a new method for improving photography; his researches complete, he
published, making no attempt to patent his innovation in Britain or abroad.
There is a good case to believe that had he chosen to, Archer could have
secured a patent. The fact that he didn't opened the way for a new wave of
market advances, making fortunes for others while Archer died impoverished
in 1857. Fox Talbot, however, a seasoned defender of patent rights, took

fig.39 Hughes and Edmonds
(Publisher)
*Sir Charles Wheatstone, Professor
Huxley, Sir David Brewster, Michael
Faraday, Professor Tyndall
Scientists, English Celebrities of
the Nineteenth Century*, 1876
Albumen print from multiple
photographs and watercolour
National Portrait Gallery (Album 216)

fig.40 Various
photographers
*Celebrities in the
Church, Science,
Literature and Art,
Photographic
Groups of Eminent
Personages, c.1867*
Albumen print from
mosaic of multiple
photographs
National Portrait
Gallery (Album 140)

1 Late Prof. Freeman, of Oxford, Historian.
2 Rev. Canon Knox Little.
3 Late S. C. Hall, establisher of the "Art Journal."
4 Thos. Henry Huxley, LL.D., F.R.S., Prof. of Natural Philosophy.
5 Late Hon. and Very Rev. Dean Stanley.
6 Sir Frederick Leighton, Pres. R.A.
7 Professor Dr. Rob. Koch, of Berlin.
8 Late Wilkie Collins, Novelist.
9 Late Lord Macaulay, Historian.
10 Late Henry Longfellow, American Poet.
11 Late Sir Edwin Landseer, R.A.
12 M. Guizot, French Historian.
13 Late Sir James Simpson, Bart., M.D., Edinboro'.
14 Late Ralph Walde Emerson, LL.D., one of the most Literary men America has produced.
15 Late Sir Moses Montefiore, Bart , well-known Jewish Philanthropist.
16 Late Shirley Brooks, Novelist, and some time Editor of "Punch."
17 M. Max O'Rell, popular French Author and Lecturer.
18 Right Hon. Lord Rosse, a distinguished practical Astronomer.
19 Late Rev. Thomas Burke, O.P., distinguished Dominican Preacher.
20 Rev. R. R. Kane, LL.D., of Belfast.
21 Aubrey De Vere, Poet.
22 Late Very Rev. Dr Walter Farquhar Hook, Dean of Chichester.
23 Late Abbe Liszt, Composer and Pianist.
24 Grant Allen, Novelist and Distinguished Writer on Popular Science.
25 Late John Tyndall, LL.D., F.R.S., Prof. Natural Philosophy, Royal Institute.

26 H.H. Pope Leo-XIII.
27 Late Thos. Carlyle, Essayist, Biographer, and Historian.
28 Herbert Spencer, Philosopher.
29 Professor J. Goldwin Smith.
30 Late Chas. Mackay, Poet, LL.D.
31 H. E. Late Cardinal Manning, Archbishop of Westminster.
32 Alma Tadema, Painter, A.R.A.
33 Late Wm Makepeace Thackeray, Novelist.
34 Late M. Joseph Ernest Renan, the French Philologist ; Author of "Vie de Jesus," &c., &c.
35 Mons. Alex. Dumas, Fils, French Novelist, &c.
36 Bret Harte, the American Writer.
37 H. E. Late Cardinal Newman.
38 Late Dr. Colenso, Bishop of Natal.
39 Late Mark Lemon, Journalist.
40 Late M. Thiers, French Historian.
41 Late Sir Rowland Hill, Instigator of Universal Cheap Postage.
42 Sir George Gabriel Stokes, Bart., M.A., LL.D., Professor of Mathematics, Univ. of Camb.
43 Sir Joseph Noel Paton. R.S.A., LL.D., celebrated Painter.
44 M. Louis Pasteur, distinguished French Prof. of Geology, Physics, and Chemistry.
45 Late Sir Morell Mackenzie, M.D.
46 Mr. F. L. Burnand, Editor of "Punch."
47 Professor Fdk. Max Muller, M.A., LL.D., distinguished Essayist, Lecturer, and Linguist.
48 Geo. MacDonald, LL.D., Poet and Novelist.
49 Late Sir Roderick Murchison, Geologist.
50 Late Rev. S. J. Perry, S.J., F.R.S., D.Sc., distinguished Astronomer, Stoneyhurst College.
51 Sir Richard Owen, D.C.L., F.R.S., &c., &c., distinguished Anatomist and Physiologist.
52 Late Charles Dickens, Novelist.

53 M. Muncacsy, Painter of the Picture, "Christ before Pilate."
54 John Ruskin, distinguished Art Critic.
55 Walter Besant, Novelist.
56 Mons. E. Zola, distinguished French Writer.
57 Robert Browning, Poet and Dramatist.
58 Sir Wm. Thompson (now Lord Kelvin), F.R.S., LL.D., D.C.L., Prof. Nat. Philosophy, Univ. of Glasgow.
59 Henrik Ibsen, Norwegian Poet and Dramatist.
60 Mark Twain, Humorous Writer.
61 Late Judge Haliburton, Author of "Sam Slick."
62 Sir Robt. Ball, LL.D., F.R.S., Astronomer.
63 William Edward Lecky, M.A., Historian.
64 Rev. Joseph L. Lyne ("Father Ignatius").
65 Sir Wyville Thompson, late Professor Natural Philosophy, Univ. of Edinboro'.
66 H. Rider Haggard, Author of "King Solomon's Mines."
67 Benjamin Ward Richardson, M.A., M.D., LL.D., F.C.A., &c., &c., distinguished Analyst
68 Right Rev. Monsignor Capel, D.D., distinguished Preacher and Lecturer.
69 Late Dr. Oliver Wendell Holmes, distinguished Poet and Miscellaneous Writer, America.
70 Late Gustave Dore, Painter.
71 Harrison Ainsworth, Novelist.
72 Professor Francis Newman, Author of the "Phases of Faith," &c.
73 Late Sir Chas. Lock Eastlake, R.A., D.C.L.
74 Professor John Stuart Blackie, Edinboro'.
75 Sir John Millais, R.A.
76 Stanley J. Weyman, Novelist.
77 George A. Sala, Journalist.
78 Late Matthew Arnold, Essayist.
79 Late Anthony Trollops, Novelist.

80 Father Theobald Matthew, the Apostle of Temperance.
81 Sir Joseph Lister, Bart, M.D., F.R.C.S. Eng.
82 Late Baron Von Humboldt, distinguished Traveller and Naturalist.
83 Oscar Wylde, Author and Lecturer.
84 Late Robert Chambers, distinguished Publisher and Author.
85 A. C. Swinbourne, Poet.
86 Late Sir Andrew Clarke, M.D., P.R.C.P.
87 H. E. Cardinal Vaughan, Archbishop of Westminster.
88 Late Richard A. Proctor, Author of the "Poetry of Astronomy."
89 Late Sir David Brewster, Natural Philosopher and Eloquent Writer.
90 Late Dr. Adler, Chief Rabbi.
91 Late Victor Hugo, Poet, Dramatist, and Novelist.
92 General Sir Henry Rawlinson, Indian Diplomatist and Oriental Scholar.
93 Late David Livingstone, LL.D., the African Traveller.
94 Late John S. Mill, Political Economist.
95 Anthony Fronde, Historian.
96 Lord Armstrong, the Great Gun Engineer.
97 Late Martin Tupper, Author of "Proverbial Philosophy."
98 Late Cardinal Lavigerie, Apb. of Carthage
99 Right Hon. Lord Tennyson, the Poet Laureate
100 Very Rev. Dr. Sinclair, Archdeacon of London
101 Late Rev Sir F. G. Ousley, Bart., Prof. of Music, Oxford.
102 Late M. Meissonier, Painter.
103 Late Hugh Miller, Geologist.

fig.41 Elliott and Fry
Captain Walter Edgeworth-Johnstone
in *Sporting Celebrities: Portraits,
Notes, Monographs*, *c.*1890
Collotype
National Portrait Gallery
(AX39966)

fig.42 Samuel A. Walker
Arthur Mason in *Dignitries of
the Church: An Ecclesiastical
Portrait Album with Concise
Biographies,* 1890
Woodburytype
National Portrait Gallery
(Album 196)

fig.43 Herbert Rose Barraud
*The Countess of Cardigan and
Lancaster, Men and Women of
the Day,* 1891
Carbon print
National Portrait Gallery (AX 28367)

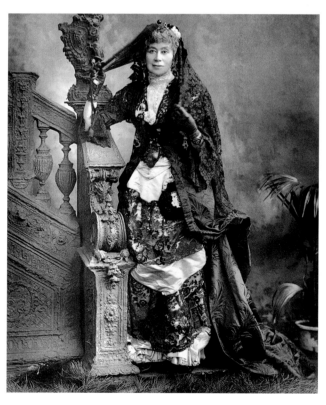

This is a representative selection of the portraits that were made for published collections of celebrity figures of the day. They were often issued in part-works, three at a time, accompanied by brief anodyne biographies sandwiched between pages of advertisements for luxury goods. These could be separated out and compiled in more lavish and appropriate bindings (see fig.37). Series editions such as *Celebrities in the Church, Science, Literature and Art* and *English Celebrities of the Nineteenth Century* were sold separately, as complete works. The actress Sarah Bernhardt was one of the few celebrities who would have been paid to be photographed. In *c.*1890 the New York photographer Sarony was alleged to have paid her $10,000 for a sitting, and the issuance of her portrait would have guaranteed sales.

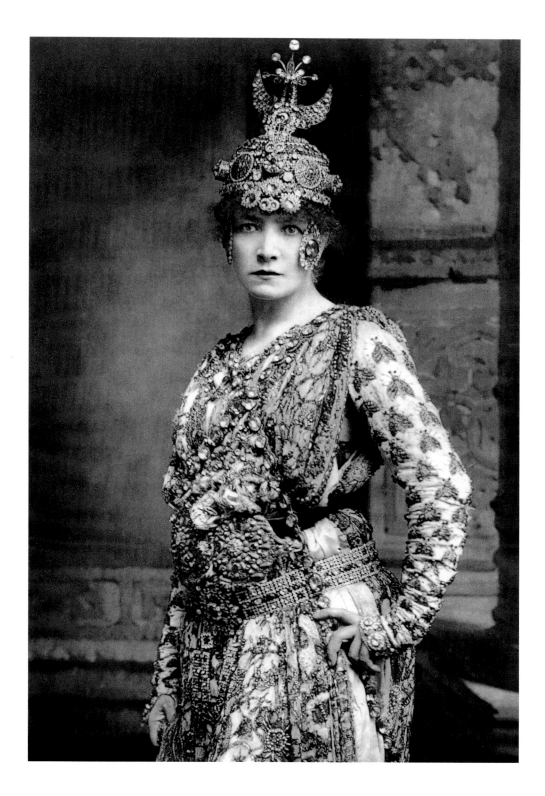

fig.44 W. & D. Downey
Sarah Bernhardt in
*The Cabinet
Portrait Gallery*, 1890
Woodburytype
National Portrait Gallery
(AX 28520)

exception, perceiving the process to be an infringement of the concept of negative and positive enshrined in his calotype pattern. In 1854, in what was to be a landmark test case, he sued the photographer Martin Laroche (1815?–86). Fox Talbot was by then gaining a reputation for thwarting the advance of photography through an over-zealous appetite for litigation. Laroche became the champion of the progressive lobby and was backed by, among others, Roger Fenton (1819–69), the founder of the Photographic Society of London. Talbot lost the case and the principle of photography in Britain was for the first time ever free from patents and open for enterprise, with immediate impact.

In London the number of photography businesses began to multiply, from twelve in 1851 to sixty-six in 1855 through to 155 by 1857 and in excess of 200 in 1860. By 1861 Paris could boast a workforce of 33,000 employed in photography and its allied trades (Linkman, 1993, p.73). While the market broadened, it also began to diversify. The high end of the business scale, catering for the more exclusive clientele, could be organised along factory principles, reflecting the division of labour between preparation, exposure, development and printing that the process demanded. Successful businesses formed clusters: there were thirty-five studios laced along London's Regent Street, New York had Broadway, Paris the Boulevards. The cheap alternative to the daguerreotype, the bleached and black-backed collodion positive, or ambrotype, was comparatively simple and could be readily made by single or two-person operators.

Photography had always attracted a rich vein of society to its ranks. The first to join were related tradesmen: opticians, engravers, artists and precision engineers. They were quickly joined by others from more diverse backgrounds who had an eye for a new market, a taste for the avant-garde and some technical grounding. Holgrave, the romantic hero of Nathaniel Hawthorne's *House of the Seven Gables* (1851) offers a valuable, albeit fictional, case study. Aged just twenty-two, from 'exceedingly humble origins' and 'the scantiest education', he had already tried his hand at being a schoolmaster, a salesman in a country store, the political editor of a country newspaper, a peddler, a dentist and a 'supernumerary official, of some kind or other, aboard a packet ship', before recasting himself as a daguerreotypist. In the 1850s the wet collodion positive could be practised as a side business allied to hairdressing, watchmaking, dentistry and grocery; a *Punch* cartoon of 1857 featured the legend *an Exact likeness & a rasher of Bacon for 6d.* (Linkman, 1993, p.30). Occasionally, the rudimentary knowledge of chemistry and physics required to be an operator was so scant, it had disastrous consequences, collodion being a solution of guncotton dissolved in alcohol and ether – the highly explosive soaked in the highly inflammable. Poor storage, careless handling and the irresistible desire to light up in the darkroom had predictable and cataclysmic effects. And there was another hazard, less spectacular and yet more invasive:

the fixing of the collodion negative required cyanide of potassium, a lethal poison which, once ingested, attacked the nervous system. 'Doors opened to the absorption of cyanide,' wrote one medical advisor in 1874, 'are doors opened to death.' (Haworth-Booth, 1992, p.90). The catalogue of maimings, burnings, madness, disease and death amongst practitioners of 'the dark art' in this period makes for alarming reading – a sobering counter-point to the image of the romanticised chancer.

The boom in self-commissioned portraiture that the collodion process facilitated was further stimulated by the fascination to see and to admire the public faces of the most well-known names of the age. The studios that clustered along the most fashionable streets, at the nerve centre of the major cities were located at the top of buildings. 'Glasshouses' became a new feature of the urban skyline. At street level, their entrances, sandwiched between the surrounding theatres and shops, were advertised by glass showcases. Into these were displayed the images of the most noteworthy clients, a free and public display of the stars of the day: actors and actresses, writers, poets, painters, politicians and, most desirable of all, nobility and royalty. These showcases attracted large crowds and stimulated a fashion for parading up and down the street admiring the stores and the stars. This blend of shopping and celebrity viewing must have been something akin to an open-air version of flipping idly through a modern glossy magazine.

The vogue for the carte de visite

The *Gallery of Illustrious Americans* (1850), the series of lithographs based on the daguerreotypes of Mathew Brady, spawned a new trend. Photographs became the basis for engravings, not only as limited editions but in the newly emergent popular press. In Britain the reduction of the stamp tax in 1836 and its eventual removal in 1855 created the ideal environment for newspapers and magazines to prosper. *The Illustrated London News*, *Punch*, *Vanity Fair*, *Illustrated Review* all flourished as did the specialist press serving the particular interests of the professional classes, such as the *Lancet*, *Nature* and *Theatre*. All featured engraved portraits usually linked to biography and commonly based on photographs, despite the fact that an engraving of a photograph is no nearer the original than an engraving of a painting. The production of cheaply made but photographic quality images in a secondary print process remained tantalisingly beyond reach. However, an intermediary stage, the *carte de visite*, emerged on the scene in the late 1850s, allowing celebrity pictures to be produced on a mass scale, then circulated, sold, collected and assembled.

The *carte* was a by-product of the collodion process and its success was a result of the increasing industrialisation of photography along the principles

of the factory. Unlike any of the preceding phases of technological develop-
ment, it relied on neither physics nor chemistry, turning instead to the most
basic principles of maths, division and multiplication. By the relatively simple
solution of designing a camera with four lenses and a rotating back, ten, eight
or six separate exposures could be made onto one glass-plate negative. When
printed, it could yield multiples of the original sub-division: ten, eight or six
positive proofs to be cut and mounted onto a card the size of a calling card,
hence the term *carte de visite*, which refers to the format as much as to the
social function of the photograph. It would seem that the notion of a small-
sized image occurred almost simultaneously to a number of innovators; but
only one, André Adolphe Eugène Disdéri (1819–89), succeeded in both
popularising and, in November 1854, patenting the process. The invention
had been conceived by Disdéri as appealing to the tastes and pocket of the
relatively untapped market of the *petite bourgeoisie*. However, the first impetus
came from the appearance not of the Parisian *arrivistes* before the quadruple
lenses, but of the most widely uttered name in France, that of Emperor
Napoleon III, although it is unclear precisely how Disdéri persuaded the
Emperor into his studio in 1859. In her exhaustively researched book
A. A. E. Disdéri and the Carte de Visite Portrait Photograph (1985), Elizabeth Anne
McCauley follows the rise of this proletarian form of portraiture from its
aristocratic origins. She found evidence that as early as 1856 'the carte portrait
was making inroads in affluent households'. Quoting the 13 September diary
entry of the Emperor's cousin, Julie Bonaparte, 'Now it is the fashion to have
your portrait made small in a hundred copies: it only costs fifty francs and
it is very handy to give to your friends and to have their images constantly at
hand.' (McCauley, 1985, p. 45). However, the appearance of this commercially
available, lilliputian-sized image of the Emperor caused a stir in Paris that
ignited a city-wide explosion for cartomania. The fashion for the *carte* raged
throughout the summer of 1859, spread across France, Europe and America
and reached its zenith in the early 1860s before it eventually declined in the
second half of the decade.

Between 1860 and 1862 Disdéri trod the familiar path of packaging his
carte portraits of the royals and their entourage into weekly instalments
accompanied by brief, anodyne biographies. As had been the pattern with
engravings, his *Galerie des contemporains* could be assembled piecemeal
through subscription or purchased in compiled volumes of twenty-five.
Others quickly followed his example. Disdéri's former employee, Pierre Petit,
teamed up with Antoine Trinquart in an attempt to photograph a list of 1500
leading figures to be included in the series *Galerie des hommes du jour*.

The evident appeal of the *carte* lay in its uniformly small size and its
relatively low price. The photographs soon became detached from their
laudatory biographies and could be bought individually from a wide range of

outlets including stationers, booksellers, print sellers and luxury goods emporia. To be depicted on a *carte* was not the preserve of the rich, powerful and famous but a pleasure open to ever-widening strata of society. By the early 1860s it was possible to visit a studio and have your image reduced, formatted and packaged in exactly the same way as that of an emperor or a queen. This apparent fluidity of status was something of a two-way street. Both Emperor Napoleon in France and Queen Victoria and Prince Albert in Britain deliberately refrained from appearing robed and bejewelled, opting instead for the increasingly ubiquitous everyday uniform of suits and crinolines. As heads of state they were well versed in the propagandist traditions of the painted portrait. Through photography they perceived a new means of imparting a more mannered modesty which camouflaged their power and wealth and re-affirmed an enduring power of re-invention in a more emancipated age of modernity. Their *cartes* sold well: between 1860 and 1862 there were sales of between three and four million *cartes* of Victoria. Downey's portrait of the youthful Princess of Wales giving her infant child a piggy-back proved a breathtakingly fresh image of royalty and sold over half a million copies. The death of Prince Albert spawned a black market in photographs after the firm of Marion & Company had sold its entire stock of 70,000 copies of the late consort in the week after his death. A visiting journalist to Marion & Company's publishing warehouse had earlier described how, 'packed in the drawers and shelves are the representations of thousands of English-women and Englishmen awaiting to be shuffled out to all the leading shops in the country.' (Prescott, 1985, pp.47). An analysis of Disdéri's *Galerie des contemporains* gives some indication of how the pack was sorted: the largest professional categories were politicians and nobility (28 percent), military leaders (10 percent), and actors (37 percent) (McCauley, 1985, p.62).

The predominance of actors is of particular interest. The theatre in both Europe and America had enjoyed a period of rapid expansion in the years 1830 to 1880. In Britain the revival of interest in the Classical forms of drama, opera and ballet was extended to embrace new types of popular entertainment such as melodrama, music hall and Christmas pantomime. New buildings opened to accommodate new audiences there to enjoy a proliferation of ephemeral and contemporary work. Slight productions were often elaborately packaged with spectacle and illusion. Louis Daguerre's name was synonymous with the Paris Diorama in the years before he became linked to a photographic process. The pension he received from the French Government in recognition of his claims to photographic invention included an additional payment for his secrets of the Diorama. This staged illusionary show was created with opaque screens and changing light effects. In the era of the *carte de visite*, photography and the theatre came to prosper through a mutually beneficial relationship. Performers flocked to the studios to have their

portraits taken as lasting mementos of transitory performances. The camera cast theatrical types in the new role of widely collected celebrities. Young and beautiful actresses were a particular favourite. Their increased fame helped fill seats and further accelerate the popularity of the theatre. Theatre duly returned the favour by introducing to portrait photography a new repertoire of gestures and poses. Unlike many other sitters, performers were at home amongst the backdrops and props, versed in the art of taking direction and took to the photographic studio as a natural extension of the stage. Their portraits created a new taste for informality and expressive gesture that enlivened the art of the photographer. Nadar in Paris and Camille Silvy (1834–1910) in London both drew on formative experiences of photographing actors and, though stylistically different, they developed as masterful directors of the physiologically charged performance. O.G. Rejlander drew on his earlier career as an itinerant actor. His portraits for Charles Darwin's *The Expressions of the Emotions in Man and Animals* (1872), in which Rejlander also appears in front of the camera, have none of the subtleties of a Nadar; instead, they rejoice in the archness of the theatrical and in exaggerated gesture. If evidence was needed of the prevalence of actors frequenting *carte de visite* studios, then it arrived in 1865. The failed actor John Wilkes Booth (1838–65) assumed a new role when he stepped from the audience during a performance of *Our American Cousin* at Ford's Theatre in Washington in 1865 and shot Abraham Lincoln. Within weeks Booth's *carte de visite* had been plucked from the back of the files, reprinted and widely distributed across America and Europe. A shocked world had the opportunity to look into the eyes of a notorious killer.

The fascination for actresses was illustrated in Emile Zola's novel *La Curée* (1871), in which Maxime 'carried portraits of actresses in every pocket. He even had one in his cigarette case. From time to time he cleared them all out and moved the ladies into an album which he left lying around the drawing room and which was already full of Renée's friends.'

This new form of collecting caught the public imagination and with it came the secondary market of albums, manufactured with pre-cut slots in which to insert the collected *cartes*. Their heavy tooled leather covers and solid brass clasps deliberately mimicked the design of the Bible and the hymnal. The established tradition of recording the births, deaths and marriages of successive generations on the fly leaf of the family Bible evolved into the family photographic album. This new visual genealogy was designed for posterity and functioned as a cherished heirloom to be handed down through the generations. In Britain at least the royal family found their way into the opening pages as the model for an idealised family structure that embodied tradition and continuity, those twin virtues of ancestry.

Inevitably ownership of an album inspired the irresistible impulse to fill it. With *cartes* printed as multiples, it became common practice for sitters to

order between a dozen and one hundred copies. These could be given out and exchanged amongst an ever-widening network of family and friends. Even the clergy saw in this an opportunity to cultivate a new custom for distributing their image for the inclusion in the albums of their parishioners and so promote themselves as local celebrities. Nadar claimed his vainest sitters were two visiting English clerics who took an age to powder and rouge themselves in preparation for their appearance before his camera. For the wealthy clients there were pictures to spare and, in Britain at least, a new practice surfaced of cutting and pasting spare *cartes* into ever more fanciful designs which incorporated line drawings, water colours and montage. As so often occurred, this emergent folk art first took root in the somewhat less than folksy drawing-rooms of aristocratic country houses and estates in the early 1860s. One such album features on its opening page the head of a woman pasted onto the body of a spider astride its ink-drawn web. The metaphor of the web, revived in our present Internet age, aptly describes an extended social network of inter-connectivity woven by a powerful matriarch. The album and, by implication, both photography and the family, act as a sticky net of entrapment for all that pass through it. For the less creative, ready-made frontis *cartes* were soon commercially available, depicting children and young people in various degrees of cloying sentimentality, soliciting viewers of the album to contribute copies of their likeness. One such frontispiece has a young boy of around four or five standing on a footstool with a bullwhip, opening the pages of a *carte* album. On an accompanying scroll is the verse 'I am no robber but a cavalier, and in a friendly cause do here appear, your portraits wanted for this book of beauty, so give it or I'll do my duty.' There were also *cartes* with which to end the album, a favourite being a photograph of frosted foliage arranged around the legend 'We do all fade as a leaf.'

The *carte* enabled a new way of visual ordering, free from the constraining formula of a pre-ordained hegemony. The arrangement of this personalised body politic, with the individual and their family placed firmly at the centre, tended to be more socially fluid and less deferential than its 'Grangerised' counterpart. Celebrity flourished and society's notables became both highly visible and valued commodities. But it was an odd kind of privilege that seemed to set the whole world in a similar context and reduce it to the same social level. This apparent democratisation of the image was the dominant new feature of the *carte de visite*. As with all trends, within a few years it had run its course. By 1864 the market had shifted. No longer the fashionable currency of social exchange, sales shrank, prices fell and the social shift headed downwards. Other formats followed, such as the larger cabinet card, but their sales were less spectacular and their popularity shorter lived.

However, there was one genre of celebrity photography which emerged

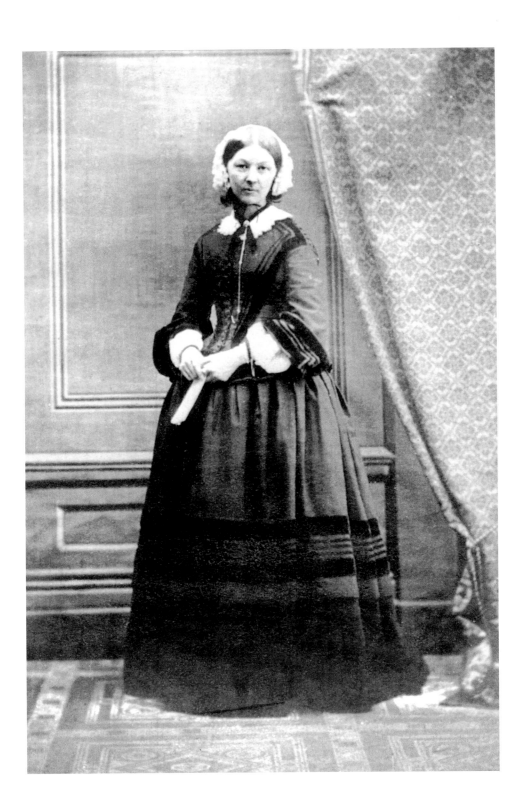

fig.45 Goodman of Derby
Florence Nightingale, *c.*1857
Albumen *carte de visite*
National Portrait Gallery
(x16139)

around the time of the *carte de visite* and endured until the very end of the century. Between 1856 and the late 1890s part-works and bound volumes of larger-scale prints of celebrities were published together with the accompanying biographies of the sitters. Their titles, formats, methods of issuance and biographic styles evolved effortlessly from the established genre of engraved portraits and letterpress biographies. Unlike the relatively free form of the self-selected *carte* album they preserved a hegemonic order with such titles as *Men of Eminence* (1863–7), and *Men of Mark*. The very newness of the media meant that only the most current public figures could be included in their pages, a fact made into a virtue in other variant titles such as *Living Celebrities* (1856–59), *Our Celebrities* (1889) and *Men and Women of the Day* (1891). Likewise, the British passion for portraiture and the prevailing preoccupation with physiognomy, character and personality had found public expression with the founding of the National Portrait Gallery in 1856. Other titles such as the *National Gallery of Photographic Portraits* (1858–9) aped this development and echoed Lord Palmerston's frequently repeated proclamation to Parliament in support of the Gallery's foundation (1856):

> There cannot, I feel convinced, be a greater incentive to mental exertion, to noble actions, to good conduct on the part of the living, than for them to see before them the features of those who have done things that are worthy of our admiration, and whose example we are more induced to imitate when they are brought before us in visible and tangible shape of portraits.

It is one of the enduring ironies that, when the Gallery's first director, Sir George Scharf (1820–95, director from 1857–95), assiduously researched and assembled an outstanding collection of portrait paintings, drawings and sculptures, he passed over the chance to acquire for the Gallery works by any of the leading photographers of the day. One of the Gallery's founding principles had been 'to soar above the mere attempt at producing a likeness, and to give that higher tone which was essential to maintain true dignity of portrait painting as art' (Rogers, 1989, p.9). Undoubtedly photography was caricatured as a mere attempt at producing a likeness, a problem compounded by the ruling that sitters, with the exception of the reigning monarchs, had to have their reputations secured by being safely dead for ten years before being included in the collection.

Scharf, however, was not immune to the private pleasures of appearing in and collecting photographs. He sat for a daguerreotype by Edward Kilburn (active 1846–62) in 1847, for Maull & Polybank, and Alexander Bassano (1829–1913) and, in 1867, after attending the Exposition Universelle, visited the Paris studios of Nadar in the Boulevard des Capucines. As well as acquiring the inevitable images of the royal family he collected *cartes* of many of the leading figures of science, politics, literature and art including Wilkie Collins

(1824–89), Charles Dickens, Richard Owen (1804–92) and Michael Faraday (1791–1867). He also bought a collection of images of French and English male athletes, walkers, runners and pugilists, who appear by modern standards of physical prowess slightly bandy-legged in their long-johns and vests. As was the common practice, he made small presents of *cartes* at Christmas and often bought the image of people he had met – he noted on the reverse of his *carte* of the Archbishop of Canterbury that he had bought it after returning from lunch with him. The front of his Nadar *cartes* have the touching inscription, 'Mother'. On being approached to appear in the next edition of *Men of Eminence*, he took the trouble of ordering several copies of earlier editions before attending the sitting (Rogers, 1989, p.10).

This process of persuading celebrities to sit for the camera became increasingly protracted. The period of negotiation between first contact and their appearance in studio could last between five months and a year. Increasingly these portrait series had to be planned well in advance with ever-lengthening lead times. As the fashion for fame took hold, more photographers and publishers honed in on the business and the most prominent names were besieged by persistent requests for portrait sittings and biographical notes. For some the lure of the limelight proved irresistible, but others became increasingly nervous. Benjamin Disraeli (1804–81), who was notoriously self-conscious and politically wise to the explicitly racist physiognomic readings of his Jewish features, fought shy of the camera. Charles Dickens, whose image was one of the most widely collected, turned down Herbert Fry's request for him to sit for the *National Gallery of Photographic Portraits*, writing in response 'I am already under conditional promises enough in the photographic way to haunt mankind with my countenance'. In a similar vein he responded to the request of John Edwin Mayall (1813–1901) to sit for the *Exhibition of Photographic Portraits of Eminent Individuals*, 'I have […] such a disinclination to multiply my counterfeit presentment' (Dickens, 1856, NPG album 39). Photographers hardened to the constant rebuffs and assumed the protective cloak of self-justification. The *Photographic News* was to claim in 1863 that a 'few years ago, Charles Dickens specified having a photograph taken as one of the latter day duties which should not be omitted'. This notion of duty was keenly felt by Florence Nightingale on her return from the Crimea. Having been eulogised in press accounts of her efforts in the military hospitals as the Lady of Lamp, she found her newly acquired fame both bewildering and distasteful. 'I often think, or rather do not like to think,' she wrote in 1888, 'how all the people who were with me in the Crimea must feel how unjust it is that all the "Testimonial" went to me.' (Small, 1998, pp.32). She nevertheless reluctantly accepted her role as figurehead of the 'Nightingale Fund' to raise public subscriptions for the establishment of a school for nurses. The collusion of celebrities was essential to the whole enterprise of published photography.

On one level there appeared little to tempt them – it was rare to be paid and only the most glamorous female stars of the theatre could expect to negotiate a fee. Until the Copyright Act of 1862 there was no control over the distribution or ownership of images. Pictures were pirated and negative archives sold on, so while a celebrity may have agreed to appear in an innocuous portrait series, there would be no guarantees regarding the suitability of future use.

The notion of the future became increasingly important as photography acquired a past. There had always been a keen awareness of posterity, of laying down the testimony of the present for the veneration of future generations. William Lake Price (1810–96) wrote in his influential *A Manual of Photographic Manipulation* (1858) that 'Posterity by the agency of photography will view the faithful image of our times; the future student, in turning the pages of history, may at the same time look on the very skin, into the very eyes, of those, long since mouldered to dust, whose lives and deeds he traces in the text.' However, photography was building a new legacy of the more complex personality constructed from multiple perspectives taken at different points in time. The newly instituted National Portrait Gallery stood for a different tradition: the selection criteria not only favoured the sitter over the artist, but focussed attention on the single iconic image as a distillation of a complete personality and an entire life. It was a creed articulated by the the artist G. F. Watts (1817–1904). 'A portrait should have in it something of the monumental; it is a summary of the life of a person, not the record of accidental position or arrangement of light and shadows.' Prior to photography only the select few would have sat for more than a handful of paintings. Where variant images of a personality were available in other media, these were, more often than not, derived from a single original portrait source. The epitaph, taken from life, inscribed on so many portrait photographs of the nineteenth century, not only underscores the essential presence of the sitter but further implies that, in the taking, the photograph has displaced the subject in order to assume a life of its own. The photograph became a legitimate substitute, capable of being transmuted into other derivative forms, as well as acting as an authentic marker against which the changing appearance, character and identity of the individual could be compared.

As portrait photography matured, it accumulated a back-catalogue from its extended reach across time. The evidence of this further crystallised the function of the image as a fixed point of comparison. With the even greater privilege of hindsight, today's audience is well versed in assuming that photography is as malleable as any other form of plastic art, whereas nineteenth-century audiences were more deeply rooted in their belief in the truth of the camera and the veracity of its image. Social and celebrity images opened the way for the portrait to act up beyond its primary function as a sign

fig.46 Julia Margaret Cameron
Thomas Carlyle, 1867
Albumen print
National Portrait Gallery (P122)

The profile of Thomas Carlyle is
indelibly marked by the signature
style of Julia Margaret Cameron.
In her studies of illustrious men, she
invariably swathed them in a timeless
cloak and cast their heads against a
dark and isolating background. In the
eyes of the Suffragettes, Carlyle was
recast from cultural icon to hated male
supremicist. The movement turned
with increasing militancy to direct
action. In March 1914 the Velasquez
painting *The Rokeby Venus* hanging in
the National Gallery was attacked
with an axe. The following July,
Annie Hunt – a woman described in
contemporary newspaper accounts
as 'of refined appearence and very
respectably dressed' – attacked the
National Portrait Gallery's Millais
portrait of Carlyle with a butcher's
cleaver.

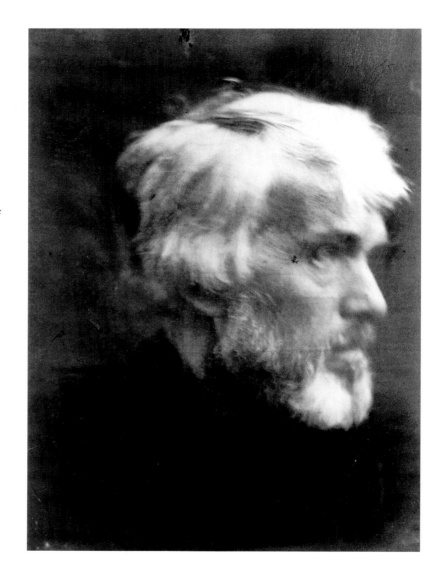

of individual identity and to place it at the centre of an increasingly complex
set of social relationships. Context became paramount.

The plethora of published celebrity images, typified by *Men of Mark*, placed
each personality within a framework of an affiliated group. As has been seen,
the genre had already become well established in a previous age. However,
photography narrowed its reference to the contemporary age and contributed
a new quality of authenticity, together with the possibility of wider inclusion
through increased quantity. To the military heroes of the Empire and the
entrepreneurial champions of industry were added the most revered
representatives of the professional classes: lawyers, doctors, academics and

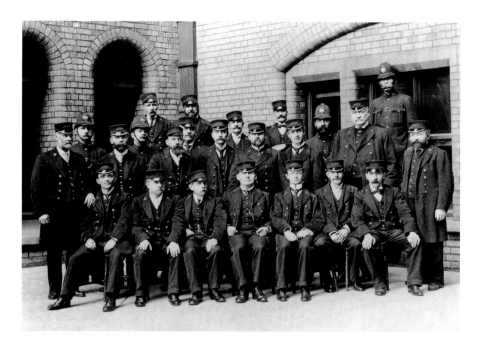

fig.47 Unknown Photographer
National Portrait Gallery Attendants and Police Officers, c.1900
Silver print
National Portrait Gallery
(Muniment store)

The account by the then Gallery Director, Charles Holmes, of the attack on Millais' *Carlyle* gives a flavour of the role of the police assigned to the Gallery and of the paid attendants. Holmes encountered 'the sergeant of Police and Attendant Wilson conducting to the waiting room a woman whose hand had apparently been cut. I asked whether an outrage had been committed in the Gallery, and the Sergeant replied, "Yes sir, a serious one."' The job of identifying and excluding potential attackers was aided by the Criminal Record Office, who issued photo charts of known militant suffragettes. The photographs were culled from a range of sources including press pictures, surveillance photographs taken in the prison exercise yard and society portrait studies.

fig.48 Criminal Record Office
Photographs of Known Militant Suffragettes, 1912
Silver prints mounted onto identification sheets
National Portrait Gallery
(Muniment store)

clerics were all perceived as adding to the wealth and physical and moral
health of the nation. Actors and artists contributed to the greater happiness.
Membership to these groups was increasingly controlled through reference,
training and qualification, and photography further aided this process by
acting as a convenient glue to help bond their collective identities and to paste
them into their rightful places in the general scheme of the great and the
good. This widening of the field of the most admired and venerated within
society implied progress and elevated the achievements of the day to new
heights from which to view the past and anticipate the future.

The damned

The collection of celebrity *cartes de visite* and their assemblage into albums
placed these heroes of the age within reach and cast them in the role of emblems
of ambition and aspiration. At the heart of the enterprise lay the carefully
constructed identity of the family, in which each member contributed to the
formation of the group. The self-sufficient nuclear family had evolved in the
nineteenth century as the urban solution to looser models of agrarian commu-
nities in which children were born and raised in a less structured way. The
wedding of Victoria and Albert in 1840 had inspired a rush towards the altar
and the percentage of families cemented together by a legally binding marriage
increased dramatically. In Britain, with the Monarchy as the guiding light, the
family assumed a greater significance and was valued as the ideal model of
social stability. Again photography helped visualise this group identity and
articulate its values of morality and endurance.
 However, the foundations of middle-class advancement, prosperity and
progress were not always stable. The hallmark of this age of capitalism was a
cyclical boom-and-bust economy, with business failure and bankruptcy on
its downside. The spectres of destitution and the workhouse lurked as the
perennial ghosts at the middle-class family feast. The institution through
photography of a venerable elite and of a normative middle class could only
fully function if their virtues were placed alongside the visualisation of vice.
'We seem to move on a thin crust which may at any moment be rent by the
subterranean forces slumbering below', wrote the anthropologist J.G. Frazer
(1854–1941) in 1900 (Briggs, 1989, pp. 34). From the very earliest days of
photography, the camera had been poked through the social surface for a
cursory glance at life below. From the 1860s onwards, its gaze became more
intent and its surveying eye applied more routinely and in a more systematic
and structured way.
 Crime, celebrity, portraiture and surveillance would converge in the most
unexpected of ways around the figure of Thomas Carlyle in 1914. He had

been one of the most influential thinkers of the Victorian age and a catalyst amongst a circle of cultural luminaries that included Dickens, Browning (1812–89), Tennyson, Ruskin (1819–1900) and John Stuart Mill (1806–73). As an advocate of the cult of heroism he was influential in the establishment of the National Portrait Gallery and had filled the first vacancy on its Board of Trustees. When he died, he was both eulogised and mourned, but as the century turned so did his reputation. For the suffragettes, Carlyle had come to epitomise the worst excesses of male supremacy. There was also the added charge that, in his private life, his obsessive treatment of *Frederick the Great*, a volume epic (1858–65) that took twelve years to complete, had compromised the health of his wife and had ultimately killed her. Carlyle, however, was a great admirer of portraiture, declaring it as the exception to the worthlessness of painting and proclaiming that 'I have found that the portrait is a small lighted candle by which the biographies could for the first time be read.' In July 1914 Annie Hunt entered the Gallery and headed for the Millais portrait of Carlyle. Her intention was not so much to read by the lighted candle as to snuff it out: she took a butcher's cleaver from beneath her coat and proceeded to smash the glass and slash the canvas. This iconoclastic act of destruction was part of a pattern of increasingly militant direct action and followed on from the infamous axe attack on the Velasquez painting the *Rokeby Venus*. The Gallery had been warned. Sheets of small-sized photographs with typed descriptions had been issued by the Criminal Record Office in a series of memoranda, headed 'Known Militant Suffragettes' and distributed to the Gallery's wardens in April and May 1914. They are particularly interesting examples of an eclectic mix of portrait styles that collectively operated as identification pictures. Some had been copied from society studio portraits, some had been lifted from press pictures taken at the scene of public demonstrations, others taken by the police at the time of arrest, while the remainder were snatched in the exercise yards of Holloway Prison. These surveillance images became the first representations of the suffragettes to be owned by the National Portrait Gallery. Its portraits of the men and women who have helped shape British history privileged the celebrity of the sitter over the merit of the artist. From the start, the founding trustees tempered their definition of achievement with the qualification that 'great faults and errors' should not bar individuals from inclusion. But the collections, first assembled in the nineteenth century, brought together the acclaimed and declared them as 'being worthy of our admiration'. If not the most beautiful they were undoubtedly the most exalted, cast in relief against the extremes of society's damned.

fig.49 G.-B. Duchenne de Boulogne
Taken from *Mécanisme de la physionomie humaine*, 1862
Salted paper print pasted on card
© Ecole Nationale Supérieure des Beaux-Arts, Paris

This photograph, taken around 1855 and possibly with the help of Adrien Tournachon, comes from the first scientific work to use photographic portraiture as an integral element of a proposed theory. Duchenne used electric stimulation of paralysed patients to demonstrate the physiological basis of expression. His caption to this photograph states that it shows 'that the combination of the muscles of *joy* and *pain*, at certain degrees of contraction, will only produce a grimace. Strong electrical contraction of *m. zygomaticus major* and of *m. corrugator supercilii: grimace*.'

fig.50 Oscar Gustav Rejlander
Self portrait, 1872
Darwin Papers, Cambridge University
By permission of the Syndics of Cambridge University Library

'Surprised person', a self-portrait by Rejlander, reproduced in Charles Darwin's *The Expression of Emotions in Man and Animals* (1872), one of the first scientific texts to make systematic use of photographs. Rejlander had been both actor and painter before making his name as a leading photographer, and his ability to mimic and photograph expressions was seized upon with enthusiasm by Darwin.

CHAPTER III

Policing the Face

PETER HAMILTON

Introduction

The invention of photography was finally announced in 1839, but the central importance to science of the pictures it could be used to create was apparent much earlier (Batchen, 1997, pp.24–53). Yet even if science deployed the image as a central part of its methods from at least the 1500s, the technology of imaging prior to photography had many drawbacks because of its dependence on human skills. Diagrams could help to inform, maps to chart, drawings and paintings to recognise, but until photography appeared with its promise of a foolproof objectivity, images could only be illustrative, for they could represent but they could not be used, in their own right, as *evidence*. Their makers had to rely upon their physical skills of eye and hand to translate what they saw in front of them into convincing depictions. The fact that photography might produce not just illustrative information but also evidential knowledge was quickly realised. It produced a paradigm shift in ways of thinking about knowledge itself, and played a central role in the success of the sciences in the nineteenth century.

The possibility of creating scientific *evidence* through the new technology was appealing not only to the sciences, but to medicine, the law, commerce and industry. If cameras could indeed generate objective knowledge, then photography might arguably play a central role in the management and control of society in general. So, as the century unfolds, we see an ever-widening deployment of the camera and the technologies of picture-making as tools of surveillance and classification. It is intriguing that this occured in parallel with the increasing demand for domestic photography on the one hand, and for a 'social portraiture' of occupational and other types on the other. There is a distinct sense in which nineteenth-century family albums can be seen as forms of the 'domestic museum', and the obsessive concern with their compilation is part of the nineteenth-century fascination with using photography to establish a complete, objective and comprehensive social inventory in a period obsessed with taxonomy and social order. Moreover the album has some interesting parallels, as a form of social inventory, with other

methods for using photographic portraits to classify and locate individuals within social categories. For as the scientific uses of photography became more apparent as a method of providing evidence, the more widely it was used to create another sort of archive, another type of 'museum', one which had as its central logic the use of classification as a means of surveillance and social control.

William Henry Fox Talbot wrote in 1839, for a paper he read at a meeting of the Royal Society, that photography would prove of value to the 'inductive methods of modern science', in that it would allow the capture of chance natural events, which might then be followed up with 'experiments, […] varying the conditions of these until the true law of nature which they express is apprehended'. From at least the early 1500s, European science had placed observation at the centre of its methods, so Fox Talbot's suggestion seems no more than part of a long tradition which saw in visual description a key element of scientific progress. Words were simply insufficient: as early as *c.*1490, Leonardo da Vinci noted on one of his drawings of a human heart: 'How in words can you describe this heart without filling a whole book?' (Cazort, 1997, p.14).

Precise rendering techniques soon emerged to make scientific illustrations, but they were of little use as tools of science, except to their maker, unless they could be disseminated in some way. It is not accidental that the histories of printing and of scientific illustration march hand in hand, for the one enabled the other to be generalised and standardised, and to figure – through the publication of books and prints – as key elements in scientific education. But until the invention of photography, illustration could as readily propagate illusion as it could truth. The German artist Albrecht Dürer (1471–1528) made a now-famous engraving of a rhinoceros in 1515, based largely on a verbal description of the animal that was more than a little fanciful. This was copied, with all its errors, for more than a hundred years after (Cazort, 1997, p.19). Printing facilitated the wide distribution of such images to such an extent that a visual error like this could be readily propagated.

The needs of science, and in particular its role in advancing human progress by revealing the true condition of natural phenomena, were (as they remain today) intimately bound up with illustration and depiction. The great achievements of seventeenth- and eighteenth-century science could not have been communicated to the growing scientific communities of Europe and North America without books and journals which carried diagrams and drawings illustrating the operation of natural principles, the forms of flora and fauna, or the applications of technology to social requirements. A striking example of this was to be found in the *Encyclopédie* (1751–72), the huge intellectual project of mid-eighteenth-century French writers and thinkers, *les Philosophes*, which comprised seventeen volumes of text and a further twelve volumes of plates (engravings illustrating nearly all of the articles in

the main encyclopaedia). This work was intended to collate and summarise the current state of human knowledge in every field, and contained thousands of relevant and carefully made engravings.

What is important for our purposes is not that such a work should have existed (for there were other similar, though less ambitious, publications available in eighteenth-century Europe), but that it represented the dominant model for disseminating scientific knowledge to a widening audience of 'enlightened' people. By offering such a model, it represented science and technology as forms of knowledge in which the *visual was an essential* element. Advances in these fields, it follows, were intimately related to their depiction. In such a context, science and art were not at opposite ends of a spectrum, but intertwined practices. It is not a surprise, therefore, that the first modern museums appear in the Enlightenment, buildings where collections of objects are placed so as to be seen, to demonstrate through visual perception important forms of knowledge. Connecting knowledge to sight and linking showing to science were essential elements of an Enlightenment world view that was both universalistic and inclusive: everything was to be part of it, and a common set of principles or 'laws' could be observed to govern its operation. Human progress involves knowing more and more about these principles, for knowledge brings with it the ability to understand and control. Classification and measurement are essential to progress, both requiring extensive visualisation and the creation of records which can be seen or viewed in a systematic manner.

The rapid expansion of science in general from the late seventeenth to the first quarter of the nineteenth centuries can thus be seen as leading inevitably to the invention of a specific science and technology of visualisation. What is most interesting is that this is also the period when other methods of 'observing' the natural as well as the social world were appearing, particularly in mathematics and statistics. In France, the Marquis de Condorcet (1743–94), a leading Enlightenment philosopher and contributor to the *Encyclopédie*, developed the first statistical measures of social phenomena. By the time photography was beginning to be used in 1839–40, the social statisticians M. A. Quetelet (1796–1874) and A. A. Cournot (1801–77) were also demonstrating, through mathematics, how it was possible to visualise statistically underlying patterns of *normal* social behaviour (normal in the sense that they were closest to the mathematical mean or 'norm'). Such statistical 'images' of society, usually presented as tables or graphs, were based on the idea that all forms of social activity could, like natural processes, be understood as conforming to 'laws' of social behaviour. Measurement and classification were essential to the use of statistics, which appeared able to disclose the 'invisible hand' underlying the operation of all forms of mass human behaviour, from the market to the crowd.

fig.51 John Thomson
Clapham Common Industries, 1877
© Museum of London

The itinerant photographer was seen
as representative of Clapham Common
Industries and included in John
Thomson's series, 'Street Life in
London'; the image was paired with
one of a man offering donkey rides.
By 1877 the *carte de visite* boom had
long since ended. The accompanying
text by Thomson and Adolphe Smith
notes that many of the photographers
who congregated on the common 'have
held higher positions, have been
tradesmen, or have owned studios in
town: but, after misfortunes in business
or reckless dissipations, were reduced
to their present less expensive and
more humble avocation'.

From such notions emerged the idea that the vast mass of society tended
to behave in essentially similar ways, but that, according to observation, it
would become evident that a significant minority might exhibit 'abnormal'
behaviour – in some cases diverging considerably from the mean or the
'normal'. This could apply to questions of health and hygiene (Quetelet
showed how city people had a higher mortality rate than country people, for
instance); or to more 'social' issues such as crime, prostitution, suicide, and so
on. For, as the century progressed, evolutionary ideas were grafted on to the
progressive, universalistic ideas about science, which had become established
during the Enlightenment, and began to be applied to the scrutiny and
control of people whose health or behaviour were considered a threat to the
development of society.

If statistics could paint a 'general' picture of society, photography seems
increasingly to have been used in the nineteenth century to create an image
which was more specific and detailed, depicting the relative uniformity of the
'normal' as well as the diversity of abnormality. The reproducibility inherent
in the photograph gave its users the ability to disseminate images of the
normal and the abnormal, and the certainty that there could be no mistakes in

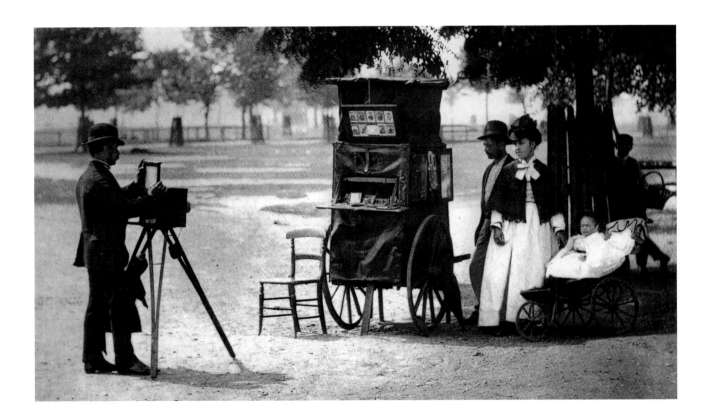

fig.52 Unknown artist
Unsympathetic Countenances, plate 12
from Johann Kasper Lavater's
Essays on Physiognomy, 1855
Engraving
National Portrait Gallery Archive
and Library

the depiction. Although it was not possible to reproduce colours, even a poor-quality monochrome image gave a better likeness of the human face than even the best artist could deliver. Belief in the existence of 'degeneracy' as a counterpart to evolution was widespread among informed opinion from the 1850s onwards. There was also a mounting fascination with how the tools of modern science such as the camera could be used to chart the visible signs of such phenomena, both among the infirm and criminal at home, and among the non-white races of the Empire. Older, pre-scientific notions about physiognomy and phrenology (how the form of the head and face could indicate predispositions) were re-modelled in the nineteenth century to make persuasive theories with a scientific flavour. Indeed there is a disturbing similarity between the ways in which doctors photographed mental patients and how anthropologists and colonial administrators (often one and the same person) photographed the native peoples under their control.

One of the most striking features of early 'scientific' photography concerned with the face and the body (up until, say, the 1880s) is that it often seems indistinguishable from current 'artistic' or 'social' photography. Take for example Dr G.-B. Duchenne de Boulogne's *Le Mécanisme de la physionomie humaine*, published in 1862. It is a comprehensive study of the muscles of the face, and their relationship with the expression of emotions. Duchenne (1806–75), a respected medical scientist, produced photographs of his experimental methods for activating individual muscles, images which are directly linked to a scientific text. His images, however, are far from neutral scientific records. They are visually striking, lit in a manner akin to that of contemporary art portraiture, and put forward as exemplars for those practising the 'plastic arts'. Duchenne also offered an *étude critique* of certain Classical

fig.53 Alphonse Bertillon
Scene-of-Crime Evidence
Photography, c.1895
a) the camera b) the body
© Musée des Collections Historiques
de la Préfecture de Police, Paris

Following the success of his criminal
identification techniques, Bertillon
developed new methods for using
photography to help in recording
relevant data from scenes of crime.
These photographs record how precise
and uniform records could be made,
using standardised techniques. They
appear to have been taken from the
display stand showing the work of the
Préfecture de Police, made for the
Exposition Universelle in Paris, 1889,
and subsequently displayed as part
of a sales drive during the 1890s for
the Bertillon system in Chicago and
St Petersburg.

busts, for which photographs were also provided. In certain editions of the
work a 'Partie Esthétique' was added, comprising photographs of a woman
acting out emotional and erotic scenes – representing, for instance, 'terrestrial'
as opposed to 'celestial' love, and various expressions which represented the
role of Lady Macbeth in certain critical scenes of Shakespeare's play.
Duchenne was deeply religious, and his strong Catholic faith no doubt
sustained him in the view that art and science were complementary activities
designed to uncover the work of a divine creator.

A closer examination of nineteenth-century photography thus reveals the
ways in which it became caught up with the dominant social, political and
scientific ideas of the age. It is particularly clear that the developmental
trajectory of scientific and pseudo-scientific photography of the human face
and body mirrors that of art and social portraiture. Conventions established
in one area influence modes of depiction in the other, so that we can see
the nineteenth-century's fascination with phrenology and physiognomy
moulding styles in studio portraiture as well as approaches to the anthro-
pology of subject races, the diagnosis of mental disease, or the identification
of criminals. The growing systematisation of photographic documentation
of the human face during the nineteenth century 'feeds back' into social

portraiture, with the latter used to present ideal types of European society against which each family or individual could compare themselves. Photography offered a means for creating systems of inclusive classification which would incorporate ever more sophisticated distinctions. As Chapter Two has indicated, the huge success of the *carte de visite* from the mid-1850s can be understood as part of this process. It comes as some surprise to find the same visual form – the *carte* itself – being used as systematically to provide 'scientific' portraits (for instance of mental patients in the West Riding Lunatic Asylum of Wakefield) as it was to record the features of Queen Victoria and her family. The later emergence of a wide range of more or less systematic classificatory sets of portraits of leading (and less exalted) figures of the age, has as its counterpart the collection of anthropological, medical and judicial portraits designed to record, classify and control subject races, degenerate bodies and deviant individuals.

Exploring the body and the mind: physiognomy, psychology and psychiatry

The idea that the human face carries indelible signs of the real character and attributes of a person is ancient. Referred to as 'physiognomy', it was first systematically discussed in a text by an unknown Classical author – still believed in the nineteenth century to be Aristotle – whose ideas were repeated in many influential works from the Renaissance to the twentieth century. The basic ideas of physiognomics connect to 'humoral' theory – the notion that four basic physiological 'humours' or essential states determine human behaviour (people may either be a 'pure' type or a mixture of the humours). The face is thus a sort of mask which may be used, through the mechanics of expression, to hide a person's true nature, but which, if it can be 'read' correctly, may be seen to display the essential nature of the person within. The common allusion to the eyes being 'windows on the soul' suggests one of the functions of physiognomy: it offers an 'architectural' model of the way in which facial expressions are constructed via the mechanisms of the head.

Expression is, of course, an extremely important component of social behaviour, and it would be misleading to suggest that even in the twenty-first century everything is now known about its physiology and its connection to the personality (or socio-cultural background) of the individual. But so important was expression considered in the nineteenth century that many scientific and other learned works were devoted to it. Even the very first photographic publication, Fox Talbot's *The Pencil of Nature* (1844–6), includes a photographic copy of an engraving by the French artist Louis-Léopold Boilly (1761–1845), a study of thirty-five grotesque, grimacing

fig.54 Alexander Bassano
William Thomson, Archbishop of York
National Portrait Gallery (x96180).

heads from his popular series of lithographs, *Collection des grimaces* (1823–8).

Classical physiognomy formed part of the study of both art and science, and included theories about the correspondence between human and animal features. Those who looked like lions, for instance, were noble and courageous; those who resembled foxes were crafty and deceitful. Giambattista della Porta (1535–1615), a renaissance polymath who perfected the design of the camera obscura, wrote in his influential *De humana physiognomonia* (1586) that the science had a divine basis, in the sense that observation of particular features of the body would allow one to discern the 'particular passions of the soul'. The French philosopher René Descartes (1596–1650) further enhanced this notion, giving it a systematic basis in 1649 by classifying the 'passions of the soul' into six classes – whose forty-one composites and extremes were later adroitly visualised by one of Louis XIV's Court painters, Charles Le Brun (1619–90), in 1678 in an enormously influential publication *Conférence de M. Le Brun sur l'expression générale et particulière*, which was handed down in various editions until the nineteenth century as the standard work on the matter. It formed the basis of Classical theatre acting, and the material from which history painters from Poussin to David drew their inspiration until the early nineteenth century.

Physiognomics also entered Enlightenment science through the writings of Johann Kaspar Lavater, whose *Physiognimische Fragmente* of 1775–8 had considerable influence on nineteenth-century thought, being widely circulated in numerous editions and translations. A Swiss theologian, Lavater believed that the face was a clear indicator of moral worth. Facial beauty was an index of virtue, and ugliness denoted vice. 'The moral life of man,' he wrote, 'reveals itself in the lines, marks and transitions of the countenance.' (Lavater, *c.*1870). For Lavater, however, passions and emotions were fugitive states, and of merely secondary interest: only by study of the static and fixed countenance might an accurate assessment of moral character be made. Lavater's ideas were to dominate European thought on the question of the expression of emotions for another century and are the context in which much early scientific photography of the face was made. Duchenne de Boulogne's work of the 1850s and 1860s, for instance, is quite expressly directed at the debate around Lavater's theories (and at Le Brun's influence on the teaching of art at the Paris Académie), but is a scientific discussion of what was in effect more of a moral than a physiological theory. Yet, as in so many areas of scientific research, 'pseudo-science' may be the spur to more profound inquiry, and Duchenne is now recognised as having made considerable advances in the field of neurophysiology. Like his Scottish predecessor Charles Bell (1774–1842), an anatomist and medical philosopher who produced a highly influential study of *Essays on the Anatomy of Expression in Painting* (1806), Duchenne's work bridged science, medicine and art. But the Frenchman's

work was intended not merely as a guide to how to show character and emotion in art, but as the first steps towards a 'physiognomical science [...] for diagnosing the patient's internal state of mind'.

The main drive of scientists such as Bell and Duchenne was to demonstrate that Lavater had been wrong to assume that the expression of emotions was a secondary feature of character: indeed they felt that it should precede the study of the face at rest, and was in most respects a better guide to character and personality. Bell had argued that 'expression is to emotion what language is to thought' – this implied that the expressions were a form of sign, a gestural index of a person's emotional state. Although he did not use such a terminology, Bell was concerned with the 'semiotics' (sign-language) of expressions, and this was an issue of some importance to nineteenth-century science, a further indicator of the complicated relationship between art and science during this period. Bell also believed that the instinctual component in animal behaviour made their expressions much less interesting to study, and was drawn to the extreme expressions to be found in dementia, a particular interest of most of those scientists drawn to the physiognomic debates of the nineteenth century. Although his medical and scientific work also led him to investigate patients in mental hospitals Duchenne was more concerned with neurological and physiological dysfunction than dementia *per se*. However, there is no doubt that his work was taken as relevant to this area of research by his contemporaries (including Charles Darwin and his colleague Dr James Crichton-Browne (1840–1938), director of the West Riding Lunatic Asylum of Wakefield, and a keen proponent of the use of photography to study the insane).

Less interested in the expression of emotions by the demented than many of his colleagues, Duchenne believed that he should study the 'normal' mechanisms of facial expression. It was probably this interest that helped to ensure that his experimental work on physiognomy remains an extraordinary, influential and often startling achievement of early photography. It was published in 1862 as *Le Mécanisme de la physionomie humaine, ou analyse électro-physiologique de l'expression des passions applicable à la pratique des arts plastiques* (The mechanism of human physiognomy, or electro-physiological analysis of the expression of passions, applicable to the practice of the plastic arts). It is clear from the title that Duchenne is addressing his work to an audience which might not be inclined to make important distinctions between artistic and scientific knowledge. There are several versions of the first publication, which comprise differing presentations of the photographs made by (or under the direction of) Duchenne. As with many such early works of photographic publishing issued prior to the introduction of the half-tone press, each copy of Duchenne's *Mécanisme* was assembled from printed text pages to which were added separate photographic prints on salted or albumen paper, varnished and pasted on to card. Some editions were bound, others contain separate text

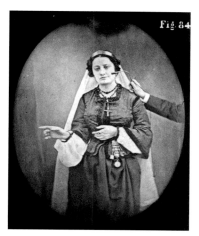

fig.55 G.-B. Duchenne de Boulogne Image from his *Mécanisme de la physionomie humaine*, 1862 Salted paper print pasted on card Private Collection

This photograph appears in the *partie esthétique* (aesthetic section) of *Mécanisme*, in which Duchenne intended to 'show a sample of what could be obtained in the realm of art and beauty, using my physiological experiments on human facial expression'. Although seemingly depicting a religious pose, in fact Duchenne took his inspiration from Shakespeare: 'Lady Macbeth – receiving King Duncan with a perfidious smile. False smile on the left, by covering the right side of the mouth. Feeble electrical contraction of the left *m. zygomaticus major* at the time when the face expressed malcontentment.'

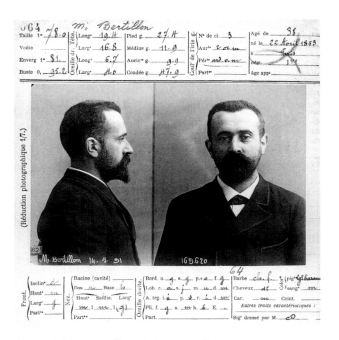

fig.56 Alphonse Bertillon, *Alphonse Bertillon*, 1891

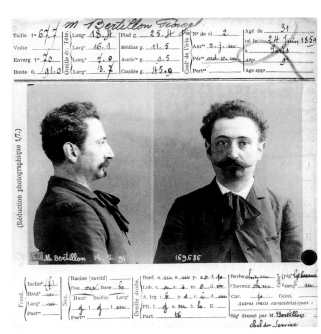

fig.57 Alphonse Bertillon, *Georges Bertillon, brother of Alphonse*, 1892

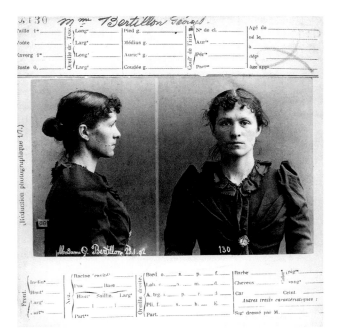

fig.58 Alphonse Bertillon, *Mme Georges Bertillon*

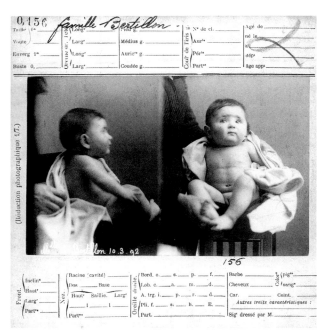

fig.59 Alphonse Bertillon, *Female child of M and Mme Georges Bertillon*, 1892

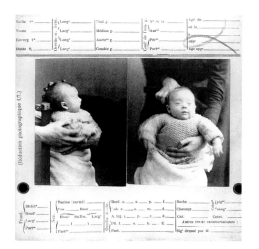

fig.60 Alphonse Bertillon
Georges Bertillon Jnr, New-born, 1893

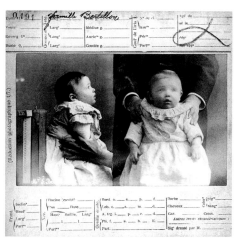

fig.61 Alphonse Bertillon
Georges Bertillon Jnr, Infant, 1893

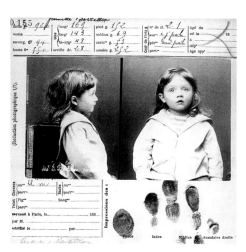

fig.62 Alphonse Bertillon
Georges Bertillon Jnr, Aged 2

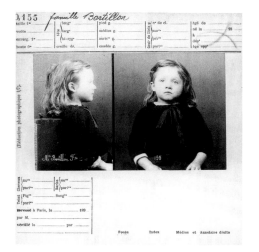

fig.63 Alphonse Bertillon
Georges Bertillon Jnr, Aged 3, 1895

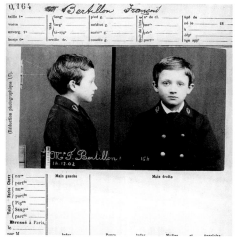

fig.64 Alphonse Bertillon
Georges Bertillon Jnr, Aged 8, 1902

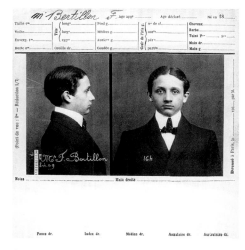

fig.65 Alphonse Bertillon
Georges Bertillon Jnr, Aged 14, 1909

As a physical anthropologist, Alphonse Bertillon was interested in the hereditary transmission of physical and mental characteristics, and these cards carrying images of various members of his own family (made according to the accepted *bertillonage* system) may well have formed part of his research. His nephew François (son of Georges, Bertillon's brother who also worked for the Paris police) is followed over a period of almost fifteen years, from birth to the eve of young manhood.

All images © Musée des Collections Historiques de la Préfecture de Police, Paris

and plate sections in an unbound form, which would have been somewhat easier to use in a studio, library or laboratory. The large 'de luxe' quarto edition has between seventy-four and eighty-four plates of single images (contact prints from the 18 × 24 cm glass plates on which the photographs were made), plus nine *tableaux synoptiques* (synoptic pictures presented in tabular form), each containing sixteen images on a page (these being assembled from the single images and supplemented with annotations, then re-photographed on a single 18 × 24 cm plate from which each *tableau* would have been contact-printed). Some plates are enlargements from an original image. Duchenne also published in 1862 an *Album de photographies pathologiques complémentaires du livre intitulé De l'électrisation localisée*. This used some of the same photographs as appear in *Mécanisme*, but in this case they were selected to accompany an earlier scientific text by Duchenne (*De l'électrisation localisée*), which had first appeared without illustration in 1855. This demonstrates that Duchenne saw his life's work on the electrical stimulus of the muscles of the face as requiring photographic illustration, if the validity of his conclusions was to be respected by his peers. His preface to *Mécanisme* makes his objectives clear:

> 'When the spirit is roused, the human face becomes a living picture where each movement of the spirit is expressed by a feature, each action by a characteristic, the swift, sharp impression of which anticipates the will and discloses our most secret feelings.' [Buffon, *Histoire de l'homme*].
>
> The spirit is thus the source of expression. It activates the muscles that portray our emotions on the face with characteristic patterns. Consequently the laws that govern the expressions of the human face can be discovered by studying muscle action.
>
> I sought the solution to this problem for many years. Using electrical currents, I have made the facial muscles contract to *speak* the language of the emotions and the sentiments. 'Experimentation,' said Bacon, 'is a type of question applied to nature in order to make it speak.' This careful study of isolated muscle action showed me the reason behind the lines, wrinkles, and folds of the moving face. These lines and folds are precise signs, which in their various combinations result in facial expression. Thus by proceeding from the expressive muscle to the spirit that set it in action, I have been able to study and discover the mechanism and laws of human facial expression.
>
> I will not limit myself to a formulation of these laws. Using photography I will illustrate the expressive lines of the face during electrical contraction of its muscles.
>
> In short, through electrophysiological analysis and with the aid of photography, I will demonstrate the art of correctly portraying the expressive lines of the human face, which I shall call the orthography of facial expression in movement (Duchenne de Boulogne, 1862: 1990, pp. xv–xvi).

Duchenne's work is quite explicitly medico-scientific in spirit. He practised as a doctor in Paris, sometimes at the Salpétrière Hospital where many

patients had conditions such as epilepsy, palsy, paralysis and insanity; but he also saw in his own and other practices people afflicted by neurological diseases and various disorders of the facial muscles. Duchenne believed that many of these disorders were due to electrical dysfunction of the nervous system and its related muscles. He was a recognised authority on neurology, experimental physiology and medicine, and the mentor of Jean-Martin Charcot (1825–93), who would in his turn come to be the teacher of Sigmund Freud (1857–1939). He wrote on the relationship between art and dementia as well as developing, with photographers Paul Regnard and Albert Londe (1858–1917), a 'visual iconography' of the insane (Cuthbertson, 1990, p.225). Alongside his medical and scientific achievements, we must also see Duchenne in the context of his times, for his ideas were deeply imprinted with his profound Christian beliefs. He saw himself as concerned with mapping the neurological and physiological structure of the human body and as discerning the design of the Creator. He felt that the language ('orthography' is his term) of facial expression was created by God.

> In the face, our Creator was not concerned with mechanical necessity. He was able, in his wisdom, or – please pardon this manner of speaking – in pursuing a divine fantasy, to put any particular muscles into action, one alone or several muscles together, when he wished the characteristic signs of the emotions, even the most fleeting, to be written briefly on man's face. Once this language of facial expression was created, it sufficed for him to give all human beings the instinctive faculty of always expressing their sentiments by contracting the same muscles. This rendered the language universal and immutable (Duchenne de Boulogne, 1862: 1990, p.19).

We know that Duchenne had some assistance in making these images around 1855–6 from the portrait photographer Adrien Tournachon, the younger brother of Félix Tournachon (1820–1910), better known as Nadar. Indeed Duchenne refers to A. Tournachon (1825–1903) in his foreword to the 'Scientific Section' of *Mécanisme*: 'M. Adrien Tournachon, a photographer whose ability is known to everyone, has been kind enough to lend me the sum of his talent to execute some of the negatives for this scientific section.' (Duchenne de Boulogne, 1862: 1990, p.39). Early versions of the work containing plates were submitted to the jury for an important scientific prize, the Prix Volta, carrying Tournachon's stamp of Nadar Jne (Nadar the Younger) in 1857 (Bula and Quétin, 1999, pp.51–66). Some historians of photography have gone as far as to discern the stylistic influence of the 'true' Nadar studio in the Duchenne photographs, but although Adrien Tournachon worked with his elder brother Félix before their quarrel and subsequent legal separation in 1855, it is now impossible to know whether Félix rather than (or possibly with) Adrien helped Duchenne to define the aesthetic style in which the pictures were made. Nonetheless it seems that the majority of the

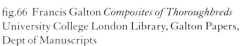

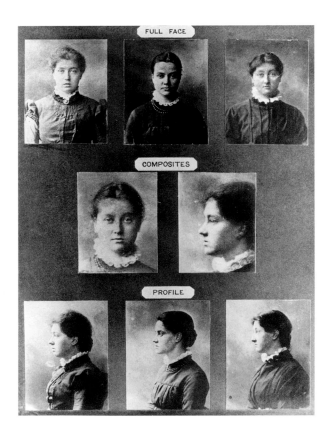

fig.66 Francis Galton *Composites of Thoroughbreds*
University College London Library, Galton Papers,
Dept of Manuscripts

fig.67 Francis Galton *Composites of Sisters*
University College London Library, Galton Papers,
Dept of Manuscripts

fig.68 Francis Galton *Composites of Members of a Family*
University College London Library, Galton Papers,
Dept of Manuscripts

All images courtesy of University College London

Examples of composite photographs made by Francis
Galton – Charles Darwin's cousin – the inventor of
techniques for using photography to record the statistical
'normality' of physiognomic features. He invented a special
camera which could record overall 'ideal–typical' features
from a large group of individual, standardised portraits
all made on the same photographic plate. Galton's work
on physiognomy is closely linked to his genetic and racial
theories, and he was one of those who proposed the use of
eugenics (a form of racial cleansing) to rid society of those
displaying 'degenerate' characteristics.

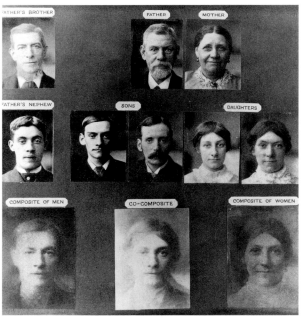

photographs which form the major work were made by Duchenne himself. He gives a careful account of how he went about the work:

> Photography, as true as a mirror, can illustrate my electrophysiological experiments and help to judge the value of the deductions that I have made from them.
>
> From 1852, convinced of the impossibility of popularising or even of publishing this research without the aid of photography, I approached some talented and artistic photographers. These first trials were not, and could not be, successful. In photography, as in painting or sculpture, you can only transmit well what you perceive well. Art does not rely only on technical skills. For my research, it was necessary to know how to put each expressive line into relief by a skilful play of light. This skill was beyond the most dextrous artist; he did not understand the physiological facts I was trying to demonstrate.
>
> Thus I needed to initiate myself into the art of photography.
>
> I photographed most of the seventy-three plates that make up the Scientific Section of this Album myself, or presided over their execution, [reference here to Adrien Tournachon] and so that none shall doubt the facts presented here. I have made sure that not one of the photographs has been retouched (Duchenne de Boulogne, 1862: 1990, p.39).

Duchenne's artistic proficiency in photography (however well tutored he might have been by one or both of the Tournachon brothers) shines through in his succinct account of the techniques he employed to create the images. He even admits that certain of the (older) photographs are technically inferior because they were made with a lens which did not have sufficient speed or depth of field to give the sharpness he required. At one point he describes how, working with an assistant, the 'experimental artist' can both pose the subject and apply the electrodes which stimulate the facial muscles: an operation 'which demands considerable artistic feeling'. Duchenne also indicates that he, and not his assistant, 'proceeds with the development of the plate' (Duchenne de Boulogne, 1862: 1990, p.103). Close observation of the prints indicates that Duchenne's fingers appear stained in a characteristic manner by the chemicals used to develop the wet-collodion plates he employed in his photography. But despite any photographic shortcomings, Duchenne declared himself satisfied with the results:

> In actual fact, these photographic imperfections do not alter the truth and clarity of the expressive lines. Moreover, we will see that generally the distribution of light is quite in harmony with the emotions that the expressive lines represent. Thus the plates that portray the somber passions, the sinister ones: *aggression, wickedness, suffering, pain, fright, torture mingled with dread*, gain singularly in energy under the influence of chiaroscuro; they resemble the style of Rembrandt [...]. Other plates, taken in plain sunlight where the exposure time could be very short, display the finer details, the shadows showing great complexity; there is again chiaroscuro, but after the style of Ribera [...]. And

there are also some very brightly and evenly illuminated photographs. These are the ones that portray *astonishment, amazement, admiration, gaiety* [...]. All the plates of the Album are fairly big so that one can see the expressive lines very distinctly: They are one-quarter natural size (Duchenne de Boulogne, 1862: 1990, p. 39).

It is difficult now to look back on Duchenne's work, with its strange mixture of the scientific, the aesthetic and the divine, and comprehend its impact on his contemporaries. That his purpose was to demonstrate a primarily aesthetic theory about the expression of emotions (which might inform and modify the teaching of art), is made even clearer when we realise that the last section of *Mécanisme*, the so-called 'Aesthetic Section', was not published until several months after the 'Scientific Section', thus permitting Duchenne to answer some of his critics. Although most contemporary reviews were laudatory, one medical critic lambasted Duchenne, finding 'the combination of artist, scientist, and worst of all photographer, abhorrent!' Nonetheless, Duchenne felt that, by presenting his models in various settings designed to evoke certain Classical poses or models from literature such as Lady Macbeth, he could demonstrate how virtue and vice might be written on the face, in a manner that would be of practical utility to artists:

> The experiment photographed [...] is a good example of this. In fact, I managed to photograph the pleasure of a pure spirit, devoted to God, owing to the general effect of her appearance: with her eye slightly obscured and obliquely upturned to the side, and with her smile and half-opened mouth, with her head and body leaning slightly backward, with her hands crossed on her breast, and with her little cross around her neck. [...] The left side thus displays a delightful expression of rapture reminiscent of the ecstasies of St. Teresa. At this point I made the muscle of lasciviousness [...] on the right contract lightly, and then the expression on this side alone assumed a charming character of sensual pleasure, more evident after the left side [*of the image*] is covered. This rapturous state no longer has an element of mysticism; we sense that it is not only the result of the delights of divine love but that the memory of her loved one exalts her imagination and her senses. This is the ideal poetry of human love.
>
> There is only a very slight difference between the ecstatic expression of celestial love and that of terrestrial love. [...] and this is something that artists have seldom appreciated. Their saints and even their virgins, painted in states of beatitude and sweet rapture, whose features should always exude innocence and purity, too often have the expression of sensual pleasure. Bernini's group representing the ecstasy of St. Teresa in the basilica of St. Peter, in Rome, is a striking example. A beautiful angel armed with a spear appears to her and everything in St. Teresa's expression breathes the most *voluptuous* beatitude (1862: 1990, pp. 110–11).

It might seem paradoxical that Duchenne's stated aim was to provide painters and sculptors with a better guide to the veridical representation of

facial expression, so that they might achieve a greater *naturalism* in their works, at the same time as he saw his work as against the 'realism' which was beginning to influence contemporary painting (and of which the Impressionists represent one strand). But in his photographs he demonstrated little more than that figurative painting and sculpture are really inadequate to a task that photography performs far better, because it is at the same time both more realistic and thus more naturalistic. His science now seems more profound than his art.

If Duchenne's artistic aims were to be negated by his photographic method, his scientific insights proved of considerable importance in developing the understanding of human evolution. His work and his correspondence with Darwin played an important part in the emergence of new thinking concerning the relationships between facial expression, emotion and racial characteristics. Charles Darwin owned two copies of *Mécanisme* (an unbound copy of the quarto volume containing seventy-four plates, but not the 'Partie Esthétique'; and an octavo version which only contains the 144 images of the *tableaux synoptiques*). He was particularly interested in Duchenne's work because it supported his universalistic ideas about human evolution: if all expressions have the same physiological source, as Duchenne's work suggests, they would be further evidence that human beings have descended from a common progenitor.

In his *Origin of Species* Darwin had shown that modern science could prove that Creationism was not an adequate account of human history. His theory of evolution led to a furore because it seemed to question the accepted religious belief in the way in which man and animals had come into existence. These beliefs were present in many works, prior to Darwin, thought to be authoritative accounts of the origins of human behaviour. He wanted to write on the expression of emotions, at least in part because of the importance accorded to the relationship between character and facial expression in his time. Many of the phrenological and physiognomic theories then current were little changed from their earlier forms (often going back, via Lavater and Le Brun, to ancient Greek sources which had minimal empirical grounding). Darwin had little time for such work, dismissing for instance a section on fright from Le Brun as an example of 'the surprising nonsense that has been written on the subject' (Darwin, 1872: 1999, p.5). But some of his targets were closer to home: the authoritative work on the matter by Sir Charles Bell, for instance, had unreflectively perpetuated creationist ideas, suggesting that man and the animals were distinct and separate creations:

> [...] man himself cannot express love and humility by external signs so plainly
> as does a dog, when with drooping ears, hanging lips, flexuous body and
> wagging tail, he meets his beloved master. Nor can these movements in the dog
> be explained by acts of volition or necessary instincts, any more than the beaming

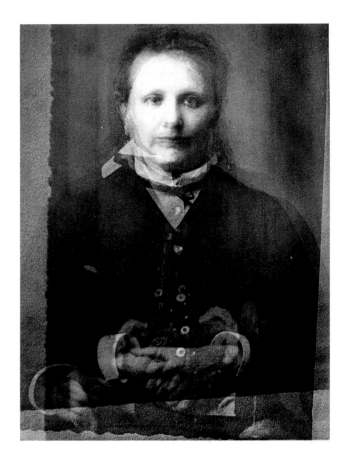

eyes and smiling cheeks of a man when he meets an old friend. If Sir C. Bell had been questioned about the expression of affection in the dog, he would no doubt have answered that this animal had been created with special instincts, adapting him for association with man, and that all further enquiry on the subject was superfluous (Darwin, 1872: 1999, p.18).

Study of the expressions, then, was a central element in Darwin's scientific project of evolutionism, and attests to the importance of attempting to understand the 'language of the face' in the nineteenth century. It was addressed to the fierce debates around evolution which his *Origin of Species* and *The Descent of Man and Selection in Relation to Sex* (1871) provoked.

No doubt as long as man and all other animals are viewed as independent creations, an effectual stop is put to our natural desire to investigate as far as possible the causes of expression. By this doctrine, anything and everything can be equally well explained; and it has proved as pernicious with respect to expression, as to every other branch of natural history. With mankind some

fig.69 Arthur Batut
*Male Members of the Family of
Arthur Batut*
Musée Arthur Batut

fig.70 Arthur Batut
*Child Members of the Family of
Arthur Batut*
Musée Arthur Batut

fig.71 Arthur Batut
*Female Members of the Family of
Arthur Batut*
Musée Arthur Batut

The intriguing composite images made by Arthur Batut from the 1880s to the early 1900s were based on the same techniques as those devised by Francis Galton. Although this photographic innovator's work was widely hailed as a method that parents could use to find out what features their children would have, Batut's interests seem to have been less 'anthropological' and more artistic in scope. He was fascinated by the ways in which the 'type-portrait' revealed common aspects of the features of different groups of people. He even applied the method to reveal what distinguished the beautiful women of Provence, especially around Arles, from their sisters in the Languedoc city of Agde.

expressions, such as bristling of the hair under the influence of extreme terror, or the uncovering of the teeth under that of furious rage, can hardly be understood, except on the belief that man once existed in a much lower and animal-like condition. The community of certain expressions in distinct though allied species, as in the movements of the same facial muscles during laughter by man and by various monkeys, is rendered somewhat more intelligible if we believe in their descent from a common progenitor. He who admits on general grounds that the structure and habits of all animals have been gradually evolved, will look at the whole subject of expression in a new and interesting light (Darwin, 1872: 1999, p.19).

It is interesting to note that Darwin was also seeking to address the forms of scientific racism then emerging, sometimes under the aegis of his own work. Those who wished to see the 'white races' as possessing any form of superiority (evolutionary or creationist) over the other races received short shrift in *The Expression of Emotions in Man and Animals*:

I have endeavoured to show in considerable detail that all the chief expressions exhibited by man are the same throughout the world. This fact is interesting, as it affords a new argument in favour of the several races being descended from a single parent stock, which must have been almost completely human in structure, and to a large extent in mind, before the period at which the races diverged from each other (Darwin, 1872: 1999, pp.335–6).

Perhaps the most significant aspect of *Expression* for our purposes is Darwin's careful use of photography to provide visual evidence in support of his theory (Prodger, 1999, pp.399–410). Among the Darwin papers in Cambridge University Library are all of the visual sources he collected for this work, including two editions of Duchenne's *Mécanisme*, and many individual photographs, some from commercial studios and others sent to him by colleagues such as Dr James Crichton-Browne of the Wakefield Asylum. But most touching of all is the collection of prints – some endorsed with annotations by the photographer and Darwin – from one of the leading art photographers of the age, Oscar Gustav Rejlander:

> The two men had met in 1871, just one year before *Expression* was published. In the course of that year, Rejlander presented Darwin with more than seventy photographs of human expression. For Darwin, who had long struggled to find photographs suitable for inclusion in *Expression*, Rejlander provided a wealth of useful photographic images. The enthusiasm and imagination with which he embraced Darwin's project transformed the content of the book, and in turn revolutionized the way in which scientists study human behaviour. As one reviewer declared, the partnership of Darwin and Rejlander had 'scattered to the winds' all previous attempts at portraying the passions (Prodger, 1999, p.399).

The collaboration between Rejlander and Darwin may have come about because both had a mutual acquaintance in the photographer Julia Margaret Cameron for whom Darwin had sat in 1868, but more significantly it was motivated by Darwin's despair at not finding adequate photographic material for his new work among the commercial pictures he consulted. In 1871 Darwin writes that he is 'now rich in photographs for I have found in London, Rejlander, who has a passion for photographing all sorts of chance expressions exhibited on various occasions.' (Prodger, 1999, p.407). An important figure in Victorian art photography, the Swedish-born Rejlander believed that the new medium might be used to create pictures with as much beauty and meaning as any other. His notorious picture *The Two Ways of Life* of 1857 demonstrates his particular skill in creating composite images from many negatives, but was berated because it depicted vice and debauchery with perhaps a little more gusto than virtue and modesty. Rejlander was highly adept at moulding the rhetoric of fine art to photographic ends and might for that reason seem an unlikely choice for a work on the objective study of the

emotions. His popular image *Ginx's Baby* (1863), though celebrated at the time as a model of 'instantaneous' photography, was in fact a photo-realistic drawing by Rejlander, photographed and distributed as a print.

Darwin's book is considered one of the first scientific texts to use photographs as part of evidence for the theory being proposed. Rejlander's contribution to it was important, but he was not the only source of imagery: there were thirty published photographs in all, of which nineteen were by Rejlander, the remainder being made by four other photographers: Crichton-Browne, Duchenne, and the commercial photographers Adolphe Kindermann and George Walich. Although Darwin indicated that he had 'found photographs made by the most instantaneous process the best means for observation, as allowing more deliberation' (Darwin, 1872:1999, p. XII), the photographic technology of the day was in fact unable to provide effectively 'instantaneous' images as we would now understand them (that is, with exposure times of $1/60$th of a second or less). A one-half to two seconds exposure was probably the limit of contemporary technology under general studio conditions, although contemporary photographers were obsessed with the idea of making 'instantaneous' pictures, and Rejlander was at the forefront of those who had developed special studio techniques for this purpose. Because of this technical problem, the images Darwin collected represent in effect more sustained expressions – and, in some cases, facial gestures created specifically for the purpose of photography and sold as 'character' images by commercial studios.

The Darwin archive in Cambridge contains more than 150 photographs, all of which were in his possession (originally kept in a package marked 'material for the Expression…'), and they comprise a very diverse set of images. They include anthropological photographs from the *Collection anthropologique du musée de Paris*, made around 1860–3. There is a fine Henry Hering (active 1850–70) portrait of a Bethlem inmate (dated by Darwin himself as having been bought from the photographer, a portraitist and print-seller in Regent Street, in 1866), and a Charles L. Dodgson (1832–98, known as Lewis Carroll) portrait of a young girl, Flora Rankin, on which Darwin has written 'Girl about 10 yrs old […] smile when told she would never have more lessons.'

Darwin's book 'played a major role in bringing photographic evidence into the scientific world' (Prodger, 1999, p. 401). Unusual in that it employed an early and costly method of photomechanical reproduction, the book also used more conventional methods of reproducing photographic images, by means of engravings made from them (two of the Duchenne images of his old man model are shown in this form, though modified to exclude his wrinkles, and to erase the galvanic instruments and the hands of the operator evident in the photographs). Perhaps Darwin was alarmed that the Duchenne images

would seem too much like pictures of a person being tortured, for taken out of context they are indeed alarming at first sight. Some of the problems of 'instantaneous' photography at this time may be seen in the fact that Darwin commissioned artists to make studies of animals for the wood engravings used to illustrate their expressions and the human emotions of fear, terror and insanity. Perhaps he thought that 'normal' human expressions were better rendered photographically. Yet the method by which they were recorded proved to be anything but simple.

In producing work for Darwin, Rejlander often used himself as model, a facility he had learned as an aspiring actor prior to becoming an artist and photographer. 'It is very difficult to get, at will – those expressions you wish – Few have the command or imagination to appear real. In time I might catch some – So I have tried *in propria persona* – even cut my moustache shorter to try to please you,' he writes when sending some material to Darwin (see fig. 50) (Prodger, 1999, p.409). It is clear that the Rejlander photographs are a mixture of the real and the contrived, although Darwin wrote that the images were 'faithful copies', and attested to their superiority to any form of drawing (though of course he was obliged to have recourse to such illustration at certain points in his book). As Philip Prodger suggests, 'Darwin was concerned that his photographs should contain as much factual information as possible, but the difficulties inherent in early photographic materials prevented the production of completely authentic documents. Given these constraints, Rejlander was the ideal choice to produce the photographs: his mastery of photographic technique bridged the gap between the desire for empirical imagery and the need for convincing illustrations.' (Prodger, 1999, p.409). But the most interesting aspect of this collaboration is that Darwin and Rejlander were working without recourse to existing rules about what a scientific photograph of the face should be: the only models then extant derived from artistic expression. In such a context it appears no more than obvious that Rejlander should employ the existing rhetoric of artistic portraiture of the face, but give it an objective or evidential meaning by using photography to record the resulting image.

As the *cartes de visite* portraits of the inmates of West Riding Lunatic Asylum produced by James Crichton-Browne might suggest, the use of photography to understand mental illness was another example of the way in which the medium adopted existing rhetorical models of portraiture, but appeared to offer new insight in so doing:

> During the eighteenth century, the portrayal of the clinically insane arose as a conspicuous genre in its own right, with depictions of the inmates of asylums occurring in increasing numbers, either as freaks evoking horrified fascination or in the context of wider allegorical, social and moral meanings. Hogarth's series of paintings and prints devoted to *The Rake's Progress* (1753) culminates in

a scene where the intemperate rake ends his days in Bedlam in the company of deranged beings who are characterized in terms of contemporary categories of insanity (Kemp, 1997, p.136).

Until the first quarter of the nineteenth century, there had been little attempt to treat insanity as a *medical* condition rather than a *social* problem. As medicine became increasingly imbued with notions drawn from Enlightenment science – experimentation, classification, universalism, progress – there was a shift from merely confining the insane in special institutions to their active treatment. Study of their condition and careful analysis of the different forms of mental disorder were recognised as respectable medical specialisms. The work of Duchenne on neurological conditions demonstrated that the study of the insane was influenced by prevailing physiognomic theories, which placed great emphasis on the interpretation of disorder from the dynamics of facial expression. In France and Britain, much attention was placed on the definition of specific types of 'mania' through careful visual recording by artists, subsequently published as engravings in certain authoritative texts such as J.E.D. Esquirol's 1838 *Des Maladies mentales*. The importance of such illustrations to the developing science of the insane may be seen in the fact that the renowned painter Théodore Géricault (1791–1824) had been commissioned in 1821–4 to make ten studies of patients with various types of 'monomania' by a doctor at the Salpétrière Hospital in Paris, where Duchenne and Charcot would later work. Yet artistic depiction offered serious problems: Géricault's work was in many ways too subtle and emotive to be used as material for a science of classification or typology.

Photography emerged at precisely the point at which science and medicine were focussing upon the insane and attempting to construct detailed typologies for their diagnosis, treatment and control. Dr Hugh Welch Diamond, a leading figure in the new treatment-centred psychiatry of the 1850s and 1860s, was also in 1853 one of the founders, with Roger Fenton and others, of the new Photographic Society, which would later become the Royal Photographic Society in 1894. Diamond was Superintendent of the Surrey County Asylum in Twickenham, and in 1852 he began a project, within the women's section, designed to use photography as part of the treatment process. He is particularly associated with the shift in thinking about psychiatry, in terms of 'mental patient' rather than 'lunatic', which began in that period. He was a noted exponent of the humane and scientific theory of 'non-restraint' (previously it had been thought essential to use irons, chains and straitjackets to restrain the insane). Once considered dangerous animals that could only be controlled, the new thinking now emphasised that they were afflicted with brain and nerve disease; that they could be cured or, at least, made comfortable (Burrows and Schumacher, 1990, p.2).

In an address to the Royal Society in 1855, Diamond made strong claims

fig.72 Lewis Carroll
Reginald Southey, Medical Student,
1858/9
© Museum of Film, Photography and
Television, Science and Society
Picture Library

Although this image may well pre-date
the publication of Charles Darwin's
Origin of Species (1859), it seems to offer
an intriguing comment upon one of
that work's central theses, that man
was descended from the higher apes.
Charles Dodgson, a mathematics don
at Christchurch College, Oxford, who
was later to become world famous
as the writer Lewis Carroll, was
introduced to the new medium around
1856 by his friend Southey; he soon
became one of the leading portrait
photographers of his era, thus enabling
him to gain an entrée into the highest
circles of the day.

for the new medium: he suggested that photography of mental patients
'makes them observable not only now but for ever, and it presents also a
perfect and faithful record, free altogether of the painful caricaturing which
so disfigures almost all the published portraits of the Insane.'(Quoted in
Burrows and Schumacher, 1990, p.154). The striking pictures Diamond made
of his patients have since entered the realms of art photography as superb
examples of nineteenth-century portraiture. They illustrate again, however, a
more revealing aspect of the use of photography as a tool of science, and that is
the very fluidity of ideas surrounding the subject-matter of scientific or medical
images. Diamond had told the Royal Society that the photographer has,

in many cases, no need for any language but his own, preferring rather to listen with the picture before him, to the silent but telling language of nature – it is unnecessary for him to use the vague terms which denote a difference in the degree of mental suffering, as for instance, distress, sorrow, deep sorrow, grief and melancholy, anguish and despair; the picture speaks for itself with the most marked impression and indicates the exact point which had been reached in the scale of unhappiness.

[…]

 An Asylum on a large scale supplies instances of delirium with raving fury and spitefulness, or delirium accompanied with an appearance of gaiety and pleasure in some cases, and with constant dejection and despondency in others, or imbecility of all the faculties with a stupid look of general weakness, and the Photographer catches in a moment the permanent cloud, or the passing storm or sunshine of the soul and thus enables the Metaphysician to witness and trace out the visible and invisible in one important branch of his researches into the Philosophy of the human mind […] The Photographer needs, in many cases, no aid from any language of his own, but prefers to listen, with the picture before him, to the silent but telling language of nature (Diamond, 1856, in Burrows and Schumacher, 1990, pp.153–4).

fig.73 The bones of a hand with a ring on one finger, viewed through X-ray, 1896
Photoprint from radiograph after Arthur Schuster
© Wellcome Library, London

 The idea that photography offered an unmediated and 'universal' form of perception seemed to promise to Diamond the possibility that pictures of this type would 'arrest the attention of the thoughtful observer more powerfully than any laboured description' (Diamond, 1856, in Burrows and Schumacher, 1990, p.153). But their utility would not rest there, for Diamond was also able to claim that he could use his pictures to therapeutic effect. By showing his patients their likenesses whilst in a condition of dementia, he hoped that they might be able to recognise how 'deviant' their behaviour had become, and understand that they were ill. In many ways this was a strikingly modern idea, and prefigured such techniques as photo-elicitation; but in another sense it merely reiterates the point that early science and early photography shared some basic assumptions about how and why the human face was being represented. Like a number of other photographers seeking to create a new form of science with their cameras, Diamond made simple portraits of his subjects, which do not depart from the accepted rhetoric of such photography in use at the time. As Martin Kemp has noted, when '[l]ooking at Diamond's actual portraits, we can see how their staging works entirely within the framework of portrait photography of the time, including the costumes and backdrops. It was the accepted nature of the conventions that permitted the attentive viewer to determine where postures and expressions departed from the decorous norm.' (Kemp, 1997, p.139).

 If the aims of portrait and scientific photography seemed indistinguishable to both photographers and scientists in the period from photography's invention until at least the 1880s, then it seems hardly surprising that science would turn

The chemist Robert Adamson (1821–48) teamed up with the painter David Octavius Hill (1802–70) to form one of the few partnerships that made professional use of Fox Talbot's calotype process. The complementary skills of the scientist and the artist combined to create a unique series of portraits. In 1843 they embarked on photographing the key protagonists in the founding of the Free Church of Scotland, intended as studies for the creation of a large-scale commemorative, historical painting. The portraits selected here are of the leading medical figures from amongst the group. They deliberately evoke notions of intellect and of philosophical introspection. By contrast, the portraits made by Henry Hering, a Regent Street photographer and print dealer, were made for a quite different purpose: they were commissioned by the Bethlem Asylum for the training of medical doctors in the diagnosis of inner mental turmoil. While the two sets of pictures share common designs and are posed in similar ways, they are meant to be read as directly contradictory evidence.

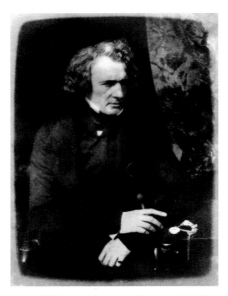

fig.74 Hill and Adamson, *Sir John McNeil, Professor of Surgeon and Diplomat*, c.1845 National Portrait Gallery (P6 (II))

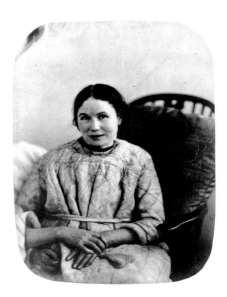

fig.75 Henry Hering, *Patient at Bethlem Asylum*, c.1855–6 Bethlem Royal Hospital Archives and Museum

to portraiture when the occasion demanded. The series made by Henry Hering at the Bethlem Royal Hospital in London is a case in point.

Henry Hering's photographs of the Bethlem patients may well have been influenced by Diamond's studies, but, according to Patricia Allderidge, the archivist of the Royal Bethlem Hospital, they were most probably made under the instruction of Dr Hood, a physician at the Asylum, between 1855 and 1858. They depict a number of people, both men and women (of whom there were a greater number in the hospital at this period), before and after treatment. At the time, Bethlem was one of the main centres for the incarceration of the criminally insane, and the subjects of Hering's photographs had all been consigned there for violent crimes. The making of these photographs is reported in an article in the *Journal of the Photographic Society* in July 1856. Hood's Bethlem colleague John Conolly also contributed an important article on 'The physiognomy of insanity', to the *Medical Times* and the *Gazette* between January 1858 and February 1859, in which Diamond's and Hering's photographs served as the basis of engravings used to provide examples in the text (Reprinted in part in Burrows and Schumacher, 1990, pp.137–52). They follow the example of an earlier work, Sir Alexander Morison's *The Physiognomy of Mental Diseases* (1843), which had employed lithographic renderings of artists' studies of the mentally ill to demonstrate the classificational power of such observations in creating typologies of the insane.

Hering's Bethlem photographs are well-executed portraits in a style

essentially similar to that being used in his studio to make commercial, 'social' portraiture for the general public. The commission also enabled Hering to make photographs of certain 'celebrity' inmates of Bethlem. One of his subjects was the painter Richard Dadd (1817–86), whose richly detailed fantasy paintings are considered to be works of genius: in Hering's famous portrait of *c*.1856 he is shown at work on his fairy painting *Contradiction. Oberon and Titania*. Hering's photograph of Dadd is indistinguishable in style and rhetorical construction from other portraits of celebrities, made in less confined circumstances.

The increasing emphasis on a 'patient-centred' approach to the treatment of insanity may well help to explain why Diamond and other early psychiatrists (such as Darwin's correspondent James Crichton-Browne) were so enthusiastic about the relevance to their work of a new technology such as photography. But they were far from alone in the view that photography was intrinsic to the 'visualisation' of most aspects of the natural and social world. 'Showing' had become very close to 'knowing' by the mid-nineteenth century, and a scientific methodology of observation and experience marked all attempts to provide information and knowledge to enlightened opinion as much as to the wider society. The development of museums and public art galleries was widely held to be, not simply an aid to trade and industry, but morally improving as well (Bennett, 1998, p.347). The museum and the gallery were also, of course, akin to the nineteenth-century factory: they concentrated the production of systems of classification, by bringing together great collections of artefacts as well as the experts capable of transforming them into a taxonomic order.

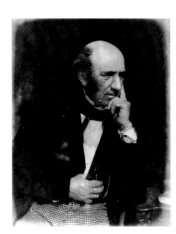

fig.76 Hill and Adamson
Robert Liston, Surgeon, *c*.1845
National Portrait Gallery (P6[19])

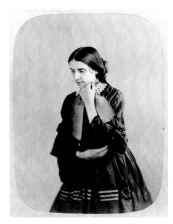

fig.77 Henry Hering
Patient at Bethlem Asylum, *c*.1855–6
Bethlem Royal Hospital Archives
and Museum

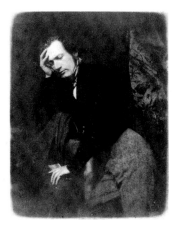

fig.78 Hill and Adamson
James Miller, Professor of Anatomy, Edinburgh, 1843
National Portrait Gallery (P6[58])

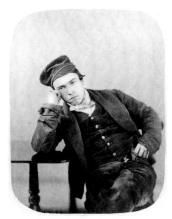

fig.79 Henry Hering
Patient at Bethlem Asylum, *c*.1855–6
Bethlem Royal Hospital Archives
and Museum

As Mark Haworth-Booth makes clear in his history of London's Victoria and Albert Museum photography collection, its genesis in the early 1850s was based on the idea of collecting photographs as part and parcel of a great institution that would teach both Classical and modern art to a new and socially wider audience which would now include the middle and working classes. Photography, as 'the New Art' which combined painterly skills with modern science, took an important place (though, surprisingly, without its British inventor, Fox Talbot) at the Great Exhibition of 1851, under the aegis of Henry Cole (1808–82), then Chairman of the Fine Arts Committee of the Society of Arts. It was, however, classified under both 'Fine Arts' and 'Philosophical instruments and Objects depending upon their Use' – that is, science. Cole made sure that all of the major exhibits were photographed, and that the published reports of the Exhibition appeared with a large number of photographic records. Some 20,000 prints were made from negatives by 155 photographers.

The huge success of the Great Exhibition led directly to the founding of Cole's South Kensington Museum in 1857, precursor of the present Victoria & Albert. From the outset, its role as a museum for the masses gave photography a central importance within the institution, both as the creator of artistic images and as a means of recording important works – indeed, the museum possessed the first 'photographic service' in the world (Haworth-Booth, 1997, pp.23–31). But the South Kensington Museum was only one of a number of such organisations. In such a context it seems hardly surprising that photography came to play a central part in recording as much of what western science wanted to visualise as could be brought before the camera.

Exploring the face: anthropology

Since medical and other sciences of the body were greatly influenced by physiognomic theories in the nineteenth century, it was widely assumed that facial indicators pointed to more fundamental proclivities and that the systematic study of their underlying mechanisms would tell science more about the basic constitution of the human being. It was in such a context that another aspect of physiognomic thinking, involving the theory of 'phrenology', as elaborated in the classic works of Franz Gall (1758–1828) and Juergen Spurzheim, came to the fore in the first two decades of the nineteenth century.

Gall's and Spurzheim's ideas were influential because they offered a modern, scientific version of physiognomy, entirely in keeping with the universalist principles of Enlightenment thinking: 'throughout all nature, a general law [decrees] that the properties of bodies act with an energy proportional to their size [and] the form and size of the brain regulate the form and size of the

skull' (Gall, F. J. and Spurzheim, J. G., *The Physiognomical System of Drs. Gall and Spurzheim; Founded on an Anatomical and Physiological Examination of the Nervous System in General, and of the Brain in Particular; indicating the Dispositions and Manifestations of the Mind*, 2nd ed., 1815, p.226). Basing their conclusions on reviews of works on anatomical and physiological science, and by carrying out their own empirical studies of the development of human and animal brains and crania, Gall and Spurzheim elaborated a complex theory which related skills, talents and character dispositions to cranial structures, locating upwards of thirty-three traits in specific parts of the brain. The visual location of these traits was initially rendered through illustration or sculpture, but photography appeared to offer the possibility of a much more 'objective' approach to the new science.

'Reading the bumps' (on the head) in a popularised version of Gall and Spurzheim's theories became a craze in the early Victorian era in England as on the Continent (Cowling, 1989, pp.40–4). As a popular science, phrenology far exceeded the limited claims made for it as an essentially neurological science by its founders, but 'it played an important part in focusing the attentions of anthropologists on the cranium, which, throughout the century, was to remain the prime index of mental capacity and racial identity' (Cowling, 1989, p.40). The 'improving' nature of phrenological knowledge, and its application to questions of social worth and order, were an important feature of the developing sciences of man:

> Phrenological societies sprang up in many leading cities, not least in Edinburgh, where George Combe and his brother, Andrew (later one of Queen Victoria's physicians), followed Gall's advice to assemble a museum of life and death-masks, and casts of the heads of notable individuals. The collection ranged from the great and good, such as Sir Isaac Newton, Jacques-Louis David, the painter and Gall himself to the notorious and evil, not least the infamous Edinburgh 'Resurrectionists', Burke and Hare (Kemp and Wallace, 2000, p.111).

As an intellectual discipline, anthropology – 'the science of man' – has spent much of its history since the early nineteenth century attempting to bridge the biological and the social sciences.

> By the third quarter of the nineteenth century anthropology had begun to establish itself as a separate discipline in Britain. Its proponents saw themselves as scientists working in the tradition of the biological sciences on the science of mankind in both physical and cultural manifestations, and applying rigorous method to their data and analysis, classification being the primary aim for the ordering and thus understanding. Evolutionism, or at least progressivism, was the dominant model in analysis. Theories of evolution also encompassed such concepts as degeneration, diffusion and recapitulation. What is important here, is that evolutionism was a highly visualised theory [...] (Edwards, 1998, p.25).

By the 1860s photography was being quite widely applied to questions of
physical anthropology, which were themselves given wider impetus by two
factors: firstly, the import of Charles Darwin's theories of natural selection
and the descent of man, which can be broadly summed-up with the term
'evolutionism'; secondly, the increasing emphasis on knowledge about and
control of subject populations within the empires of the western nations.
There was considerable debate, within the emergent discipline of anthro-
pology, about the nature of the human race: was it one race as Darwin had
suggested in *Descent* and *Expression* or several? And how was it to be
conceived in evolutionary terms – as a natural progression from lowest
(Australian aboriginal) to highest (upper-class Anglo-Saxon male), or by some
other scheme? There is a neat temporal coincidence in the invention of
photography and the formation in 1837 of the Aboriginal Protection Society
(later, the Royal Anthropological Institute), occurring within two years of
each other. And, contemporaneously, the period from 1840 onward is one of
major colonial expansion, which sees the dramatic rise of the British Empire
to its position of global hegemony by the end of the century. Photography
played a key part in the processes by which Empire was explored, surveyed,
mapped, and brought back to the metropolitan centre, to be visualised and
popularised as an idea.

> Visitors to the first exhibition of the Photographic Society in London in 1854
> were, according to one reviewer in the *Art Journal*, greatly impressed by a range
> of human portraits, including 'the Zulu Kaffirs' by a Mr Henneman and 'the
> insane' by Dr Hugh Diamond. The ability of photography to apprehend
> visually the human body made it one of the most powerful mediums in the
> Victorian era for bringing the British viewing public imaginatively face to face
> with people different from themselves, both abroad and at home. Commercial
> photographers in particular tapped into a market hungry for portraits of exotic
> and little-known peoples from around the world. Much commercial activity,
> although often focused on the picturesque, was also closely associated with
> discourses on ethnology and anthropology. Such pursuits owed their existence
> in large measure to colonial expansion and the resulting exposure of different
> races to European eyes. The institutionalization of anthropological inquiry
> through the establishment of organizations such as the Aborigines Protection
> Society (1837) and the Ethnological Society of London (ESL) (1843) was
> accompanied by an increasing concern with securing accurate and reliable
> anthropological information (Ryan, 1997, pp.11–27).

Photography featured as an integral component of colonial exploration
from at least the early 1850s, and for officially-sponsored expeditions – such
as David Livingstone's (1813–73), to chart the Zambezi (1858–64) – it was
considered essential that a photographer (as well as an artist) should be
included in the team. This was necessary, David Livingstone wrote to his

brother Charles (the chosen photographer), in order that the expedition should:

> secure characteristic specimens of the different tribes [...] for the purposes of Ethnology. Do not choose the ugliest but (as among ourselves) the better class of natives who are believed to be characteristic of the race [...] and, if possible, get men, women and children grouped together (quoted in Ryan, 1997, p.146).

The anthropological and geographical uses of photography to survey and explore unknown peoples and unknown lands were related to colonial interests (which were, in many cases, their pretexts), but seem to have received their greatest impetus from the desire to incorporate 'natives' of all sorts within the wider schemes of human classification.

As we have seen with physiognomy and phrenology, those practicing the 'new sciences' of man required extensive data in order to realise their scientific aspirations. Colonial exploitation opened up vast new populations as much to scientific study as to economic exploitation, and although the need to organise and control was clearly important to the task of classification of racial and other types, the 'taxonomic imperative' of Victorian science appears to have been sufficient motivation in itself to promote anthropological photography. Some of this was driven by philanthropic 'protectionist' interests: the creation of anthropological learned societies in London in the 1830s and 1840s was directly linked to fears that (following brutal treatment at the hands of settler populations) the 'aboriginal races' were threatened by the onslaught of 'civilisation', and that examples of them should be recorded before they were wiped out forever. A commercial photographer from Hobart, Charles Woolley, was dispatched to Tasmania to record the last few, imprisoned Tasmanians in 1862, in order that images of them might figure on display at Tasmania's stand at the Intercolonial Exhibition in Melbourne in 1862 (Ryan, 1997, p.140). His photograph of a Tasmanian woman, Truccannini, looking defiantly at the camera lens in a full-face pose, was displayed in a carefully vignetted style not unlike a banal studio portrait, and became famous after its use in a number of books about the demise of this people. But it was only included in one of a series of images, for Woolley had been commissioned to make full-face, three-quarter-face and profile portraits, in line with an emergent model of how such images might figure within a system of anthropometric evaluation. The original model for the full-face and profile head-shot comes from physiognomic illustration, but was not immediately used for recording racial types.

Although the role of photography as part of scientific observation of racial difference is recognised as early as 1852 in a British Association for the Advancement of Science *Manual of Ethnographic Enquiry*, there was initial confusion as to how 'likenesses' should be taken. It was not until the creation

fig.80 Alphonse Bertillon
*System for Photographing the Criminal and
System for Photographing the Scene of Crime*
Musée des Collections Historiques de la
Préfecture de Police, Paris

The photographic identification
service of the Préfecture de Police in
Paris was founded in 1874, and rapidly
accumulated photographs of criminals,
suspects, victims and others. They were
collected at least in part because the
practice of branding prisoners (so that
they could be marked for life, and thus
easily re-apprehended) had been dropped
in the 1850s. However, the heterogeneous
nature of many of the images made
them difficult to use, and it took the
appointment of the anthropologist
Alphonse Bertillon to the post of Chief
of Judicial Identity in 1879 before an
effective method for using photography
was developed. His system came to be
called *bertillonage* and embraced photog-
raphy as the final element in a series of
precise measurements and classifications
designed to fix the criminal within a
complex net of statistical and visual data.

fig.81 *Portrait of Feet, Affaire van den Berg*
Musée des Collections Historiques de la
Préfecture de Police, Paris

As Bertillon further developed his
various systems of classification of
criminals for the Préfecture de Police,
he introduced new methods for using
photography as a means for creating
accurate evidential records. His
innovative ways of photographing
crime scenes could be linked to identifi-
cation records and, in the case of the
feet shown here, were used to convict
the murderer (who had traces of blood
on his toenails from the murder scene,
where a photograph had been taken
showing a bloody footprint in the
victim's room). The original print of
this photograph shows the blood traces
retouched with red dye, and would
have been used in the court as evidence
in the case against the accused.

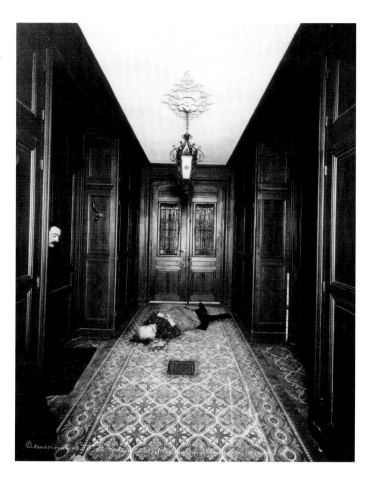

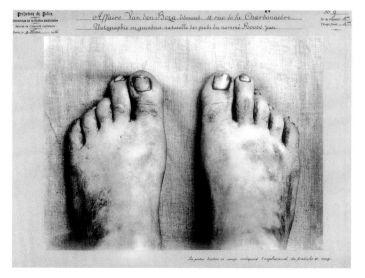

of the Anthropological Institute in 1874 (following a long period of schism between the two main anthropological bodies in the United Kingdom) that a new textbook, *Notes and Queries on Anthropology, for the Use of Travellers and Residents in Uncivilized Lands*, was issued. It gave photography an important place in the work of anthropological research, and, in a similar text written by the anthropologist E. B. Tylor for the Royal Geographic Society at about the same time, we find photography being proposed as a means of typifying specific cultural groups:

> where the general likeness of build and feature is very close, as may be seen in a photograph of a party of Caribs or Andamaners, whose uniformity contrasts instructively with the individualized faces of a party of Europeans [...] The consequence is that the traveller among a rude people, if he has something of the artist's faculty of judging form, may select groups for photography which will fairly represent the type of a whole tribe or nation (quoted in Ryan, 1997, p. 148).

By this time there was general concern that, although photography was an invaluable tool for recording differences between racial types, to become fully scientific it should be able to deliver quantifiable information. Science was progressing, it was argued, precisely because it offered a mathematical model of the world in which precise measurement played a critical role.

> Francis Galton exemplified this during his expedition in Africa in 1852–54 when he exercised his passion for exacting measurement on an African woman. In his account of his expedition, Galton referred to a Nama woman, the wife of one of his host's servants, as a 'Venus among Hottentots'. Being 'perfectly aghast at her development' and being a 'scientific man', Galton was 'exceedingly anxious to obtain accurate measurements of her shape'. However, the circumstances were difficult and Galton reported that he 'felt in a dilemma as I gazed at her form'. The solution, of which Galton was particularly proud, involved his taking a series of observations 'upon her figure' with his sextant, making an outline drawing while she stood at a distance under a tree. Then he 'boldly pulled out' his measuring tape to calculate the distance and worked out the results using trigonometry and logarithms (Ryan, 1997, p. 144).

Galton (1822–1911) was later to become an extremely important figure in the development of the 'scientific portrait' and its use in varying forms of social inventory and control.

The need for rationalised and standardised systems of measurement using photography was justified in part at least by the great significance accorded to cranial measurement in mid-nineteenth century anthropology. In 1868, the *Anthropological Review* reported that one of its correspondents had accumulated since 1848 more than 1500 human skulls for his collection. Although nowadays racism is conventionally associated with differences

figs.82–83 Murderer and victim
Albumen *cartes de visite*
Musée des Collections Historiques de
la Préfecture de Police, Paris
In the file containing these photographs
are the following details of the crime:

Murder: 10 September 1879
Victim: LENOBLE, jewelry dealer,
26 rue St Sebastien
Author: PREVOST, Victor, born at
Normant (Seine et Marne),
11 December 1837. Policeman at 75 rue
Riquet. Arrested 11 September 1879.
Sentenced to death on 8 December
1879, executed on 19 January 1880.

As the photograph shows, Lenoble's
head had been severed from his body.

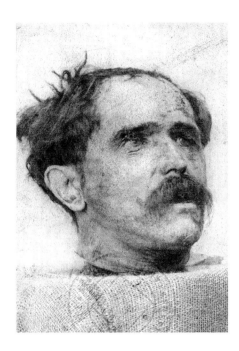
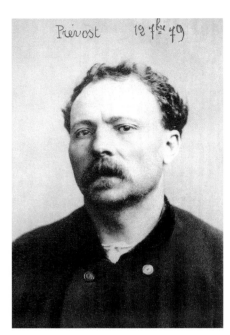

figs.84–85 Murderer and victim
Albumen *cartes de visite*
Musée des Collections Historiques de
la Préfecture de Police, Paris
In the file containing these photographs
are the following details of the crime:

Murder: 25 April 1877
Victim: PICHON, Clémentine aged 21,
35 rue de Viarmes
Author: ROBERT, Louis Aintoine,
born Paris 17 February 1849. Optical
engineer, 35 rue de Viarmes. Arrested
26 April 1877. Sentenced 30 July 1877
to 20 years of hard labour.

The victim's body has been photo-
graphed so as to indicate the nature
of her fatal injuries. These pictures
were made before the invention of
Bertillon's anthropometric system
and indicate the diversity of styles in
which criminal photographs were
made before the advent of a more
standardised scientific approach.

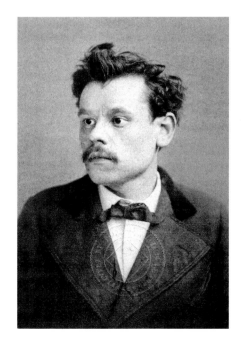
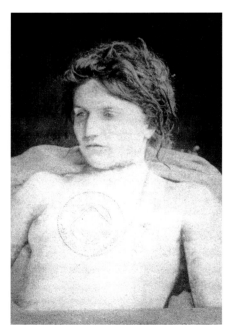

based on skin colour, by the early 1800s the skull had replaced skin colour as
the basis for racial classifications in anthropological science. Various complex
'indicators' of intellectual and moral ability were, in some physiognomic
and phrenological systems, reduced to simple factors such as the angle of a
forehead – taking over earlier models, such as Petrus Camper's (1722–89) 1768
classification of crania 'in a regular succession' from apes, at the lowest angle,
to 'divers Europeans' at the highest. Indeed, such factors as the shape of the
head were consistently considered throughout the nineteenth century to be
critical to evaluations of intellectual power. Intellect, brain-size and skull size
were thought to be intimately linked characteristics. Within such systems of
thought, non-European cranial features could be represented as indicating
inferior attributes. After Darwin's demonstration of the descent of man from
primates, such ideas seemed to be confirmed by evolutionism; for example,
the idea that any features within their cranial structures which appeared to
make particular human groups seem closer to the apes could be taken to
imply that these groups were inferior in evolutionary terms to the white
European ideal.

In 1869, the anthropologist J. Lamprey wrote a brief paper for the *Journal
of the Ethnological Society of London*, in which he described a system of
anthropometric measurement using photography. He used a measuring
screen made up of a grid of string divided into two-inch squares, against
which a naked subject was to be photographed full-length in both side view
and profile – a device similar to the grid employed by draughtsmen and
painters since the Renaissance. Lamprey's system was expressly designed to
help in classifying racial types, and he suggested that they enabled racial
comparisons to be made: 'the anatomical structure of a good academy figure
or model of six feet in height can be compared with a Malay of four feet'.
Although not widely used, it was quite influential as a system of codifying
the new 'rhetoric' of scientific anthropology. At much the same time, the
evolutionary biologist T. H. Huxley (1825–95) began an ambitious (and
ultimately unrealised) project, supported in part by the Colonial Office, to
collect a systematic photographic portfolio of the 'races of the British Empire'.
In India, jewel of the Empire, a massive project to collect a systematic photo-
graphic portfolio of *The People of India* was undertaken by the colonial
administration between 1856 and 1868. Of the 200 sets published, half were
retained for official use. J.W. Kaye and J.F. Robinson of the India Office
assembled the almost 500 images included in the work from amateur and
commercial photographers who had worked throughout the Indian sub-
continent, as well as ethnologists. Although unsystematically constructed,
this major work was widely displayed (both in London and at international
exhibitions) and helped to underpin the idea that the Indian sub-continent
was itself a grid of racial, tribal and caste 'types'. Many of the texts which

describe the photographs employ physiognomic or phrenological terms to link the appearance of the persons photographed to an understanding of them as Colonial subjects: the Pachada tribe of north-western India, for instance, is described on the basis of a single photograph depicting one individual, whose 'countenance is extremely forbidding, and perhaps an index to the lawless and unreclaimed nature of his tribe' (Ryan, 1997, p.156).

Any idea that racial theories were confined to the study of Colonial or exotic peoples is rapidly dispelled by looking at the considerable attention devoted to race and class in Britain by anthropologists in the 1870–1900 period. As James Ryan has shown in his work on photographic visualisation of the British Empire, the camera was also increasingly used to survey the indigenous population of the British Isles. An Anthropometric and Racial Committee was set up in 1875 by the British Association for the Advancement of Science. Its objective was 'the Collection of Observations on the Systematic Examination of Heights, Weights &c., of Human Beings in the British Empire, and the Publication of Photographs of the Typical Races of Empire' (Ryan, 1997, p.151). It is of considerable interest that this great taxonomic project was designed to cover the entire Empire, but in the first instance it confined its attentions to the United Kingdom. Perhaps this was because there was great domestic concern about 'national character', which appeared in the desire to confirm the natural supremacy of the 'Anglo-Saxon' or 'Teuton' race, thought to have 'conquered' early Britain. The superior qualities of the 'Anglo-Saxon' would go some way to legitimating the dominance of the English within Britain and in giving racial justification to Imperial expansion.

> In 1882 a newly established 'photographic committee' declared its faith in the scientific value of photography in representing 'a clear definition of racial features' and in the relevance of such work to a number of 'social questions' concerning the 'tendencies and proclivities' of classes as well as races. It was suggested, for instance, that the work might aid the 'exact description of criminals and deserters; resulting, it cannot be doubted, in more frequent arrests'. Thus the delineation of national racial 'types' was closely linked to the categorizing of particular social groups in Britain (Ryan, 1997, p.168).

The project was carried out using the now established convention of rigorously posed, full-face and profile views of the subject. It was widely used, despite its relatively unsystematic nature, to develop the idea that 'types' could be found within the 'races of Britain'. Of the three types which were identified, one – 'type C' – was regarded as demonstrating 'a correct definition of true Saxon features'. And where were these 'types' to be found? When the committee reported its findings in 1882, it claimed that 'photographs conforming in all respects to the above characteristics have been obtained from Sussex and several other English counties' (Ryan, 1997, p.169).

A growing interest in typological themes is also increasingly evident in the art and literature of the time. The work of social reformers was illustrated photographically; for example, *London Labour and the London Poor* by Henry Mayhew (1812–87) – which lay claims to objectivity by describing itself as 'a photograph of life as actually spent by the lower classes' – utilised engravings drawn from daguerreotypes by John Beard, and went so far as to identify certain trades (such as costermongers) as composed of people from 'a distinct race with their own physical appearance, habits and language' (Ryan, 1997, p.166). A later example would be *Street Life in London* (1878–9) by John Thomson (1837–1921), a highly popular work by a photographer best known up until then for pioneering ethnographic studies of racial types in India and China.

Ideas about race and type mapped, in most cases quite neatly, on to a developing interest – in Britain as in other western countries and to be found amongst scientists and administrators and enlightened opinion everywhere – to devise and utilise rational systems of population and social control. Such systems, underpinned by photographic methods of identification, would allow the development of much surer and more humane methods for apprehending criminals, controlling prisoners, treating the insane, and limiting the spread of the congenital disabilities which were thought to be at the heart of social degeneration and its attendant vices – crime, poverty, disease.

fig.86 *Birmingham Prisoners, c.*1860
Ambrotypes
© West Midlands Police Museum,
Birmingham

Birmingham was one of the first police forces in Britain to use photography to record the faces of criminals. As early as 1848, less than a decade after its invention, portraits were being assembled for judicial use. As these slightly later ambrotype pictures indicate, however, early identification photographs are indistinguishable from portraits made for other purposes. The long exposure times tended to make all sitters appear rather dazed, and were notorious at the time because they could make even the most innocent person appear to be possessed of a demonic nature.

Exploring the face: criminology and the degenerate

In the many findings drawn from the 53,000 observations made as part of the studies carried out for the British Association for the Advancement of Science (BAAS) project on the British population's physical characteristics, as reported in 1883, there is a clear tendency for the results to focus upon a link

between physical and mental attributes. If we look at adult male stature alone, we find a ranking which runs from Metropolitan police near the top down to 'idiots and imbeciles' at the bottom. This might also be placed in a wider comparative context: 'the committee ranked the average stature of the different races and nationalities of the world, including "Negroes of the Congo", "Irish – all classes", "Hindoos" and "Andamanese", noting "It is interesting to find that, with the exception of a few imperfectly observed South Sea Islanders [...] the English Professional Classes lead the long list, and that the Anglo-Saxon race takes the chief place in it among the civilised communities."' (Ryan, 1997, p.170). Perhaps more disturbing is the attempt by the BAAS study to measure the 'degeneration' of social groups via an index of 'nigrescence' – the presence of negroid physical attributes, at the time widely held to be a sign of physical and mental degeneracy (Ryan, 1997, p.179). Such ideas clearly served ideological as well as scientific purposes. Within both the scientific and the popular physiognomic literature which abounded in mid- to late nineteenth-century Britain are many works (from learned tomes to the pages of *Punch* magazine) in which the Irish are represented as a type with various pejorative depictions, as in the analogy between 'the Irishman' and a terrier dog in *Comparative Physiognomy* (1852) by James Redfield.

A leading figure in the BAAS's Racial Committee was Charles Darwin's cousin, Francis Galton. A leading biological scientist of his day, he had taken a considerable interest in Colonial exploration in South Africa (1850–2), where his notorious obsession with the dimensions of the 'Hottentot Venus' was manifested. The experience of the expedition, he was later to write, 'filled my

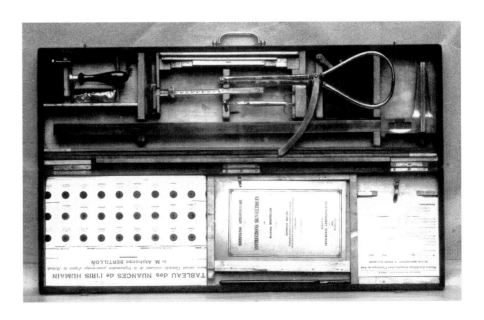

fig.87 Bertillon's measuring devices
© Musée des Collections Historiques
de la Préfecture de Police, Paris

The Bertillon system developed in Paris in the 1800s and 1890s relied upon precise and standardised measurements of many parts of the body, which, when placed on a card with full-face and profile pictures of the person's face and head, offered something Bertillon called a *portrait-parlé* (talking portrait) of the individual.

thoughts at the time with enlarged ideas and new interests, and it has left an enduring mark on all my after life' (quoted in Ryan, 1997, p.172).

A complex relationship exists between Galton's and his cousin's work on evolution and human characteristics. Galton was fascinated by questions of heredity and the human type. But he was also interested in the numerous issues to do with wider social concerns about the 'degeneration' of European populations, which developed in the mid-nineteenth century. There was widespread and increasing concern throughout the next half century that such a process of degeneration had set in, as the counterpart to the optimism, evident in theories about evolution, progress, reform and improvement, which so mark the era (Pick, 1989, p.2). The publication in 1857 of an important and influential work by the French medical doctor, Dr Bénédict Augustin Morel (1809–73), *Traité des dégénérescences physiques, intellectuelles et morales de l'espèce humaine*, ignited a debate about the decline of France in the period from 1850, which had considerable influence in the emerging fields of psychiatry, criminology and anthropology. A resulting 'degeneration' debate raged across Europe, and its powerful appeal to the natural sciences influenced by evolutionism explains at least partly the mounting concern to survey the lower, criminal and diseased classes, which were felt to be threats to the wider health of society (Pick, 1989, p.3).

It is in such a context that we need to examine Galton's work, which employed photographic techniques to serve a theory about human degeneration. Galton had been so impressed by Darwin's *Origin of Species* that he shifted his attentions from geography and meteorology to 'the very biological foundations of human society'. In the process he developed one of the most influential theories of what is called 'social Darwinism' (the application of Darwinian evolution and natural selection theories to human society). He had been interested in such issues before *Origin of Species* (as demonstrated by his mathematical fascination with the 'Hottentot Venus'):

Galton came home to England and turned his insatiable desire for numbers and measurements increasingly towards domestic 'problems' of inheritance and anthropometry informed by Darwinism. He suffered a succession of 'maladies prejudicial to mental effort', culminating in a breakdown in 1866; amongst other disappointments, it was in this period that it became apparent that his own marriage was likely to prove infertile; he became ever more fascinated by the question of evolution and inheritance at large, urging Britain's transformation from 'a mob of slaves, clinging together, incapable of self-government and begging to be led' [...] into a new race of 'vigorous self-reliant men' [...]. In Galton's work, deeply troubling questions about the nation's level of social and political maturity, and specifically about the effects of a changing and widening electoral constituency after 1867, were deflected onto the problem of the racial body and mind; politics was dissolved into mathematics and biology (Pick, 1989, p.197).

fig.88 *Portraits of Prisoners*
(Wormwood Scrubs), *c.* 1880
© Crown. Reproduced by kind
permission of H. M. Prison Service
Museum

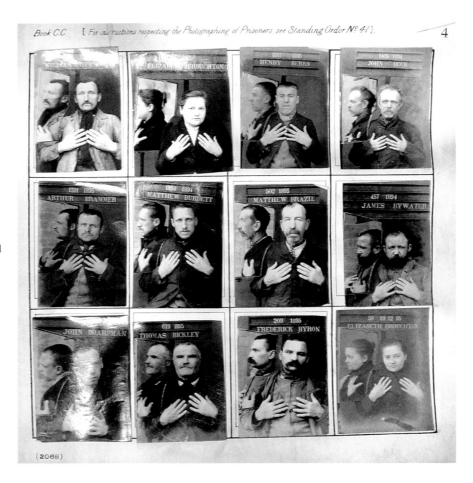

Prison identification photographs were
made in order for the authorities to
have a likeness which could be used to
catch absconders and to check recidivism.
By the 1860s anthropological photography
had borrowed the physiognomic
convention of full-face and profile
as a means of attempting to draw
'measurable' information from the
photograph. Much nineteenth-century
interest in penal administration followed
ideas about the criminal classes being
'racially' or 'genetically' different from
the rest of respectable society, and used
this interesting device to give a mirror
image of the individual's profile at
the same time as a full-face shot. It is
interesting to note that hands were seen
as a useful element of identification
from the late 1860s until the early 1890s,
when a new 'Bertillon-style' form of
prison identification photography
was introduced. The Home Office
regulations that accompanied this intro-
duction specifically proscribe showing
the subject's hands in the photograph.

Galton, therefore, was deeply involved in attempts to observe and measure
large swathes of the population, and from 1865 was employing photographic
devices of various types in order to advance his researches, which included a
large amount of cranial measurement. In 1877, his work on the BAAS Racial
Committee led him into a more detailed examination of the 'degenerate
mental type', and particularly that of the criminal. He obtained some
photographs of prisoners from Edward du Cane, the Inspector of Prisons, and
began work on devising a new system of physiognomic record which would
show the features common to three types of criminal: violent criminals, felons
and sexual offenders. His interest in mathematics and statistics had led him to
experiments which would offer an 'averaging' of physical characteristics in a
single image, so that the 'normal' distribution could be observable in the same
way as a graph might indicate how a population's characteristics were related
to their statistical mean – via a bell-shaped curve, for instance. His system

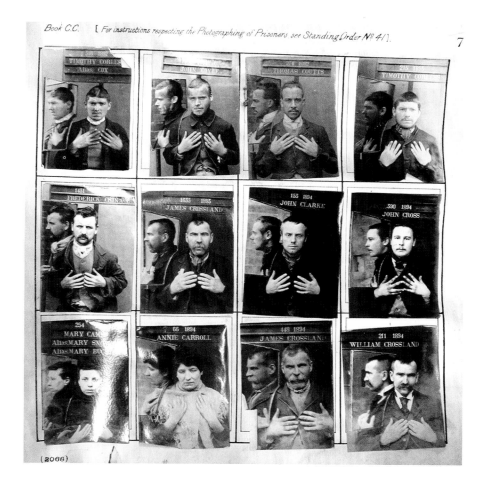

involved the re-photographing of portraits of criminals on the same plate by
successive multiple exposures, so that a composite image would be created
and this 'photographic mean' would offer an image of the 'type'. He noted
that these types meshed nearly perfectly with the 'different physiognomic
classes'. Yet the resulting images, he found, seemed more attractive than any
of the individual portraits: 'The special villainous irregularities in the latter
have disappeared, and the common humanity that underlies them has
prevailed. They represent, not the criminal, but the man who is liable to fall
into crime.' (Galton, 1878, p.135.)

The discovery of 'composite' photography enabled Galton to devise
grandiose experiments in order to compile a huge amount of data to support
his theories about degeneration. The composite image, made by taking very
short multiple shots, would offer a method of synthesising the characteristic
physiognomies from numerous individuals of a particular class or race:

criminals, consumptives, the insane, public schoolboys, Jews, were among his chosen subjects. 'It is the essential notion of race that there should be some ideal typical form from which the individuals may deviate in all directions, but about which they chiefly cluster. Now there can hardly be a more appropriate method of discovering the central physiognomical type of any race or group than that of composite portraiture.' (Galton, 1882, pp.26–31). Some of the results of this work were published in 1880, in Galton's *Inquiries into Human Faculty and its Development*, where he also began to display the fruits of his studies of collected family photographs designed to demonstrate the hereditary transmission of physiological and psychological attributes. In 1882 he issued a circular letter to amateur photographers, requesting that they send him individual photographic portraits of as many family members as possible. All were to be taken under rigorous conditions, full face and profile. In return, contributors would receive a composite portrait of the 'family like-ness'. By assigning statistically derived 'weights' (calculated from his analyses of hereditary 'laws') to the amount of exposure each relative was allotted in the composite image (and in consequence the influence their image would have on the subsequent composite), Galton claimed that he could produce an 'Ideal family likeness' (Green, 1987, p.12).

In this way photographic portraits of individuals could be used alongside other forms of measurement, such as those derived from 'Life History Albums' that Galton had designed and which he imagined could be compiled by the family or a doctor for each child. Together they could be used to gauge what was, for Galton, the 'condition of the race', and become part of the methodology he employed to support his theory of 'eugenics'. His major concern was with the inheritance of natural characteristics and the consequences of the imbalances which existed between the rates of reproduction of the various strata of Victorian society. Galton believed that the 'residuum' (that portion of the working class which, through mental and physical weakness, could fulfil no useful function) represented a biological problem for modern society, constituting a reservoir of disease and deficiency that threatened the 'hereditary complexion of the nation' (Green, 1987, p.9). The basic proposition of eugenics was that this residuum should be separated out from the rest of society, cared for in special institutions, but above all prevented from procreating and thus from degenerating the race.

The influence of Galton's ideas was quite widespread, and his method of composite photography excited interest everywhere that the physiognomic paradigm held sway. In France, the photographic innovator Arthur Batut (1846–1918) further developed Galton's composite methodology. In his treatise *La photographie appliquée à la recherche et à la réproduction du type d'une famille, d'une tribu ou d'une race* (Photography, applied to the identifica-tion and the reproduction of the type of a family, a tribe, or a race) (1887),

Batut offered a system which was designed to reveal the local characteristics of specific groups, as well as more 'racial' and cultural traits. His composites, made in the immediate vicinity of his home near Toulouse in south-west France, involving from as few as five to fifty subjects, were used to show how, even within a small area, different physiognomic groups could be identified; for instance, in comparing composite portraits he had made in the Arles area of Provence (where he was trying to capture the culturally popular, legendary beauty of the *Arlésienne*, supposedly comprised of a mixture of Roman and Saracen blood), with those made in the port of Agde in the Languedoc (where the population was thought to be Greek in origin). Batut suggests that

> the first [composite] gives an oval face, delicately modelled, with fine features, the gentle physiognomy allowing a carefree soul, clear as the fine provençal sky, to show through. The second presents a triangular face, powerfully defined, with firm, almost hard features, from an energetic physiognomy on which can be discerned an iron will that no obstacle in its path will bend. Agde, ancient Greek colony, has always depended on the sea, and for all the middle ages and most of the modern period has had to fight with the pirates that infest its coasts' (Batut, 1906: 1992, p.7).

It is clear from a correspondence around 1888 with Dr Paul Topinard, a leading French physiognomical anthropologist, that Batut had anthropological interests in mind with his system. Topinard was in charge of the Sciences anthropologiques section of the Paris Exposition International of 1889, and welcomed Batut's work, which was evidently comprised of both individual portraits and composites – the latter he wanted to show in order that 'we can demonstrate that we in France can do composite photography as well as Mr. Galton in England' (unpublished letter, 12 June 1888). Topinard offered a number of suggestions to Batut as to how he could make his individual and composite work more rigorously scientific, in order for it to be displayed at the Exposition: in essence, by making full-face and profile portraits, and by ensuring that his women subjects would not be photographed with 'white bonnets and scarves around their necks' (unpublished letter from Topinard to Batut, 12 June 1888).

One of Batut's principal interests seems to have been in using his technique to demonstrate physical characteristics, and he expressly states that his composite portraits are a form of *virtual reality* or 'images of the invisible', and that they are designed to reveal physical, non-intellectual, analogies. In particular, this will explain why he found the uses of the composite-portrait approach by Cesare Lombroso (1835–1918) in Italy most objectionable; primarily, it would seem, because the portraits were designed to make direct, physiognomical connections between physical characteristics and mentality. Lombroso's *l'uomo dilinquente* (1876) is a classic work in the nineteenth-century tradition of degeneration literature, for it bridges the important gap

between physiognomic anthropology and criminology in ways suggested by Galton's theories but not at that point taken to such extremes.

Lombroso was trained as a medical doctor and served in that capacity during the unification struggles in Italy and later in the campaigns against brigandage in the South. He had considerable experience of social medicine, and was especially concerned with the prevalence of pellagra and cretinism in Calabria. From 1862 he conducted large-scale research into the ethnic diversity of the Italian people, through anthropometric studies of the soldiery. His writings on such conditions and on the problems of unification increasingly stressed the racial diversity of the peoples who made up the new Italian state. Although not the only northern Italian intellectual to do so, his writings came increasingly to offer a scientific basis for the 'atavism' or backwardness of the peoples of the south or Mezzogiorno. As one of his disciples, Niépce Niceforo, would later write in a work entitled *Northern Italians and Southern Italians* (1901):

> Not all the parts which compose [Italy's] multiple and differentiated organism have progressed equally in the course of civilisation; some have remained behind, due to inept government or as the sad result of other factors and are unable to advance except at great effort, whilst the others have progressed dynamically. The Mezzogiorno and the Islands find themselves in the sad condition of still having the sentiments and customs, the substance if not the form – of past centuries. They are less evolved, and less civilised than the [society] to be found in Northern Italy (quoted in Pick, 1989, pp.114–15).

During the 1860s and 1870s, Lombroso was responsible for mental patients at several hospitals in the North, and by 1876 held a chair in legal medicine and public hygiene at Turin University. But by then he had made the discovery which was to make his name. In 1870, he had been trying to research the anatomical differences between criminals and the insane. Examining the skull of the notorious brigand Villela (often described as the Italian version of Jack the Ripper), he had a sudden flash of insight:

> This was not merely an idea, but a revelation. At the sight of that skull, I seemed to see all of a sudden, lighted up as a vast plain under a flaming sky, the problem of the nature of the criminal – an atavistic being who reproduces in his person the ferocious instincts of primitive humanity and the inferior animals. Thus were explained anatomically the enormous jaws, high cheek bones, prominent superciliary arches, solitary lines in the palms, extreme size of the orbits, handle-shaped ears found in criminals, savages and apes, insensibility to pain, extremely acute sight, tattooing, excessive idleness, love of orgies, and the irresponsible craving of evil for its own sake, the desire not only to extinguish life in the victim, but to mutilate the corpse, tear its flesh and drink its blood (quoted in Pick, 1989, p.122).

Phrenology and physiognomy could prove, according to Lombroso, that criminality was the sign of a primitive form of nature within a modern society and an advanced civilisation. One of the crucial pieces of evidence for this view is displayed prominently in *L'uomo dilinquente*: a series of composite photographs, inspired by Galton, of criminal skulls, demonstrating their anachronistic structures. The criminal existed in modern society, but as a natural type was a throwback: and in this sense Lombroso's is another version of the degeneration thesis presented by Galton, and central to social Darwinism. Photography was called into action both to measure the 'stigmata' of atavism (evidence of the primitive condition of the subject), through the composite portrait, and to display the features of those individuals who most clearly showed that they were of the 'criminal type', in the form of large tables showing photographic portraits of convicted criminals. In this way Lombroso intended to establish a scientifically valid, and thus foolproof, method of establishing, by the observation of 'stigmata', whether someone accused of a crime was guilty.

Lombroso's ideas were influential in Italy and convinced many in Europe and America of the fruitful connections between phrenology/physiognomy and the identification of those inclined to atavistic or criminal behaviour. But they were also increasingly contested, and alternative models of criminal anthropology emerged in other settings, based too on physiognomy, but drawing different conclusions about the best methods of identifying those individuals most prone to commit a crime. The physiognomic model seems to have reached its apogee in the system developed by Alphonse Bertillon (1853–1914) at the end of the century in France.

The use of photography to record the likeness of criminals can be dated back to at least 1841, according to contemporary reports in both Britain and Germany, which describe the employment of daguerreotypists for such purposes (Henisch and Henisch, 1994, p.297). The Brussels police are known to have made portraits of those they arrested in 1843, and their counterparts in Birmingham were doing the same by 1848 (Phèline, 1985, p.53). The development of the positive–negative system of photography, and in particular the diffusion of the *carte de visite* process, seems to have encouraged much wider use of the camera to create and distribute likenesses of the criminal from the mid-1850s. It is in this context that a noted French journalist and writer on photography, Ernest Lacan (1829–79), argued in 1856 that a wider use of the new medium by the police would be beneficial. 'Which outlaw could thus escape the vigilance of the police? Whether he escaped from the walls where he had been confined for punishment, or after being freed, had broken the ban on leaving his place of residence, his portrait would be in the hands of the authorities; he would not be able to escape; and would be forced to recognise himself in this accusing image.'

fig.90 *Street Life in London*
Cover
© Museum of Film, Photography
and Television, Science and Society
Picture Library

fig.91 John Thomson
Street Advertising
© Museum of London

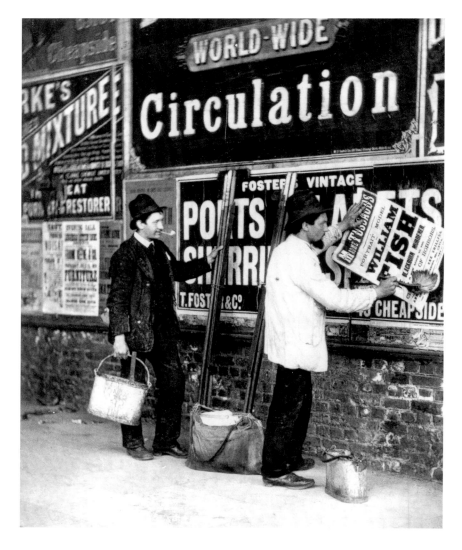

Lacan alludes to the preoccupations of those for whom 'recidivism' is a
mounting social problem, whether in France or in the other leading nations of
the western world. Notable photographers and scientists were, as we have
seen, concerned with making portraiture a scientific technique for collecting
evidence. Most penal systems in the nineteenth century followed a similar
pattern of rationalisation and systematisation, and new forms of social control
were introduced via the prison, the asylum and the hospital. These are part of
a major shift in the type of disciplinary power which society could exert over
its members (see the writings of the French philosopher Michel Foucault
(1926–84), most notably, *The Birth of the Clinic* (1963) and *Discipline and*

fig.92 Eugène Atget
Wire Basket Peddler
© Bibliothèque Nationale, Paris

fig.93
Fruit and Vegetable Seller Identity Card
Musée des Collections Historiques de
la Préfecture de Police, Paris

The ubiquity and universality of the
Bertillon system, by the early 1900s,
can be seen in its usage to regulate
street trades, such as this *marchande
aux quatre saisons*, who was photo-
graphed by the Parisian police for her
identity card. In 1940, after the fall
of France to the Germans, both the
occupying power and the Vichy regime
imposed on the entire population a
system of identity cards using
photographs of this type.

Punish (1975)). Yet such processes seem not to have occurred in a direct or
smooth transition from an older and more traditional model of repression to
a rational system of bodily discipline. One element of the approach taken by
Foucault places particular attention on how new 'sciences of man' were intent
on making prisoners, the insane and the diseased 'visible' to modern science.
The slow and complex ways in which photography came to be part of new
systems of judicial discipline, is itself revealing of some of the problems of
this perspective.

Although increasingly widely employed as a method of storing and dissemin-
ating likenesses of criminals from the 1840s, there was little systematisation of

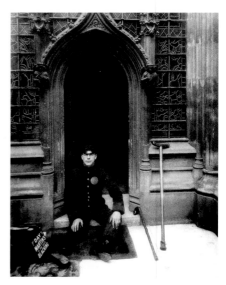

fig.94 John Thomson *Street Doctors*
© Museum of London

fig.95 Benjamin Stone
House of Commons Boot Black
National Portrait Gallery (x29908)

either the method of making such portraits or their use before the end of the
nineteenth century. For much of the period, criminal portraits or 'mug-shots',
as they came to be known as in America, seem to have been indistinguishable
from portraits made for other social purposes. Indeed, the argument that they
should be as convincing as an ordinary portrait must have applied. Photography
was generally considered a useful tool for identifying criminals, but it took a
long time before any standardisation of the criminal portrait began to emerge.

In France the founding of an official photographic department in the
Préfecture de Police took place in 1874. It came shortly after the repression of
the Paris Communards in 1871, which was aided by the incarceration and
subsequent photographing by the Versailles photographer Eugène Appert of
several hundreds of men, women and children who had been part of the
movement. Such pictures were used to demonise the Communards, through
inventive photomontages of the 'crimes' of the Commune made for commercial
sale. But, more importantly, they also served as elements in the assembly of
sets of rudimentary criminal records by the military authorities in charge of
the repression. Appert's pictures are some of the first police images to attempt
a consistent rhetoric of identification, the subjects posed either full or three-
quarter face with the plain background of a wall. What is interesting is
that in these and other police or judicial photographs of the same period,
the convention of full-face and profile had not yet been established. Indeed,
Appert's work lacks the precision of contemporary anthropological

photographs. Potteau, photographer at the Musée d'histoire naturelle in Paris and working under the influence of prevailing conceptions of physiognomy, had been making ethnographic photographs employing the full-face/profile convention in 1860–1.

Alphonse Bertillon (1853–1914) was a physiognomic anthropologist (and member of a family which counted notable scientists and statisticians among its members) before joining the Paris police service in 1879. Many of his ideas were forged in the debates around degeneration and the 'criminal type' to which Galton and Lombroso had contributed so much. The tenor of his researches in the field may be judged by the fact that he published a work on *Les Races sauvages* (*The Savage Races*) in 1883. Until that point, no police or judicial service had developed a systematic method for using photographs as part of their systems of records, and it is important to note that, initially, Bertillon was far less interested in photography than he was in anthropometry. Yet he recognised that the main problems in identification of criminals lay, not in the problems of making good photographic likenesses, but in being able to classify or compare them: by 1883, some 100,000 images had been collected by the service since its foundation, yet they were very difficult to use, being classified only by name or crime. In Britain, by contrast with France, police departments used photographs in many different ways until the 1890s by which time a system akin to that of Bertillon's was introduced. Some degree of standardisation occurred earlier in prisons, which from the late 1870s started to employ, according to instructions issued by the Home Office, a curiously designed yet effective mirror device so that a full

fig.96 Benjamin Stone, *House of Commons Furniture Attendants*
National Portrait Gallery (x29976)

fig.97 Benjamin Stone, *House of Commons Fire Brigade*
National Portrait Gallery (x30362)

face and profile portrait could be made on the same plate. It continued until Bertillon's model became the norm under new Home Office regulations in the early 1890s.

The obsessions of physiognomic anthropology with measurement and statistical order were the main motivation for Bertillon's innovatory system of identification. Photographs thus became the final element in a total system of identification operating by measurement and comparison. Bertillon had realised that criminals could disguise themselves, could experience injury or surgery, which would alter their facial form, and even have removed the tatoos by which Lombroso, for instance, set much store for identificatory purposes. *Bertillonage*, as it came to be known, offered from 1883 a simple card-based system complemented by a systematic, strictly uniform photographic technique which could be practised throughout the judicial system. The card listed a wide range of physical characteristics, including cranial measurements, ear, lip and nose shape, iris colour and, after 1892, the fingerprints of the person photographed (another of Galton's inventions), together with exact one-seventh scale photographs. It offered, complete with its standardised full-face and profile image of the criminal, what Bertillon described as a *portrait parlé* (spoken portrait), which was an almost infallible guide to identity (Bertillon, 1892, p.2).

The system of *bertillonage* proved highly successful during at least two decades of development, up until the Great War of 1914–18, and continued in use for long afterwards in France. It was exported to several other countries (including the USA and Russia) and influenced prison photography in England, where a new system using similar forms of standardised full-face and profile photography of the criminal was introduced around 1895. Indeed it is probably due to Bertillon that the full-face 'identity' photograph has become so widespread throughout the world as the standard method for identifying individuals on passports, driving licences, identity cards and credit cards. What began in the mid-nineteenth century as a method of anthropological classification had become the dominant metaphor of photographically supported identity by the twenty-first century.

Bertillon's application of measurement and classification to the photographic portrait was accompanied, in the early 1900s, by a new technique of scene-of-crime photography which he evolved from the *photographie métrique* recently invented for military surveying and mapping purposes. Metric photography involved the use of a special camera equipped with a wide-angle lens, and a large 20 × 24cm plate which would capture considerable detail. (Intriguingly, this camera was of the type later to be used by Bill Brandt (1904–83) to make his famous series *Perspective of Nudes* from the 1940s to early 1960s.) The contact prints made from these negatives were placed on specially engraved cards from which precise measurements could be taken, bearing in mind the

focal length of the lens employed and the consequent scale of reduction. Photographs were made of the crime scene itself, and of the victim where it was a case of a homicide. The most fascinating and horrifying of these often lurid images were those popularly known as *cercueils* or coffins, which were used to photograph the faces and bodies of cadavers. The card, engraved with a scaled box which gives the impression that one is looking down onto the dead victim's face, offers an undertaker's eye view of the subject, a macabre portrait with the coffin's sides as its frame.

Conclusion

The long journey of photography, from its unsteady but promising beginnings in the 1840s to the fixing of identity in a legally binding form by the early 1900s, is the story of its gradual but difficult and often hesitant incorporation within the frame of science. Yet science itself, despite its huge demand for objective techniques of visualisation and depiction, was never sure of what it needed from photography, nor of the best methods to deploy the new technology. Recording the face may have played a vital part in much of nineteenth-century thought, but it was also caught up in the constant debates between those who believed in progress and the positive benefits of science, and those who were pessimistic about the future, and fearful of the consequences of industrialisation and revolutionary change. The portrait photograph played an unexpectedly large part in all this, being called into action on a number of fronts as a method for assessing the impact of the great ideas of Victorian society: evolutionism, phrenology, degeneration, scientific positivism, to name only a few. But what may seem most fascinating of all, is the intimate connection between photography's artistic uses and the role that many wanted it to play in providing scientific evidence. We have become used to seeing art and science as opposing traditions, but it seems a novel idea that an artist such as Rejlander could have made an impact on the work of the greatest scientist of his age, Charles Darwin. From the jaundiced perspective of the twenty-first century, it may even seem odd that a scientist such as Duchenne de Boulogne should create a scientific work on physiognomy with the express purpose of improving knowledge in the 'plastic arts'. But it is from such sources that our present use of photographic technologies has evolved, and even in the most banal of photographic portraits created for our driving licences and passports, we can discern a trace of those influences.

fig.98 Alexander Bassano
Wilson Barrett, actor-manger
National Portrait Gallery
(x96388)

CHAPTER IV

Conclusion: Template for a New Order?

PETER HAMILTON

By the end of the nineteenth century, photography was the defining representational medium of its age. In Europe as in North America (and in much of the Empire, as well as in China and Japan) the ubiquity of studio portrait photography had meant that, by 1900, large swathes of society were subject to the camera's gaze. In this process the photograph had become a common currency of social identity, a recognised and accepted method of fixing likeness in a way which ensured that the image captured social information as well as physical resemblance. It played an increasing key role in the methods by which social inventories of many types were created.

There can be little doubt that photographic portraiture's rapid rise to popularity encouraged its diffusion to other spheres. The simple idea that 'the camera never lies' was widely believed in the nineteenth century, and by comparison with all other types of representation seemed to be supported by the evidence offered by photographs themselves. Because photographs are traces of real events (although this does not stop them being traces of 'false' real events as well), their role as data within the new sciences and technologies was secured. Yet the adaptation of such a visual form of knowledge into systematic methods of experiment and understanding was never as straightforward in its trajectory as it had seemed to Fox Talbot, when he claimed during the rosy dawn of photography in 1839, that it would prove of value to the 'inductive methods of modern science', and would apprehend the 'true law of nature which they express'.

Portrait photography was employed in the nineteenth century as a central method of recording information about individuals in a society which placed great significance on observation and classification within almost all walks of life. The huge appetite of the nineteenth century for taxonomy (the science or practice of classification) was largely justified in the emergent social and human sciences – from anthropology and biology to economics, politics and sociology – by their common use of 'typological' thinking. Classifying things in the natural world had produced very useful concepts, such as species and genus, and had allowed medicine, for instance, to isolate diseases and ailments.

Taxonomy generated typology, and by offering a classification of 'types' it helped 'positive' science to order the physical universe and make it meaningful. The idea that science is a 'positive' form of thinking originated with Auguste Comte (1798–1857), who argued that all sciences evolved through three phases: emerging from primitive and theological thought, via the use of metaphysical ideas, they eventually reach a point where they achieve the status of 'positive philosophy', considering 'all phenomena as subject to invariant natural laws. The exact discovery of these laws and their reduction to the least possible number constitutes the goal of all of our efforts.' (Comte, 1830–42, p.8). Ultimately, Comte suggested, all sciences would become 'positive' and unify into a single natural system. A central component of positivism, as it develops from Comte's theory into a way of thinking that many writers have described as the 'philosophy' of nineteenth-century science, is its emphasis on experience and observation as evidence for the existence of natural laws. Photography, then, as a technology and practice of observation, increasingly fits neatly within such a model of how 'positivist' science developed and progressed. This may well explain why the term itself was so often synonymous with the concept of objectivity, a notion encapsulated in the dictum 'the camera never lies'.

Comte, and those influenced by his ideas in Europe and America (who included the great liberal thinker of mid-nineteenth-century Britain, John Stuart Mill), believed that it would only be by developing the 'social' sciences along the positivist model that society could be understood – and then, in turn, improved. Although he distanced himself from Comte, the leading social Darwinist, Herbert Spencer (1820–95), followed this argument in proposing that it would only be by applying science to society that beneficial change could be effected. Spencer's theories relied upon evolutionist ideas, and argued that progress took place as a result of competition between individuals (much as competition between species is the motor of evolution in the natural world). It was a view that encouraged liberal, *laissez-faire* economic and social policy (in other words, the market will solve, if left to itself, all problems through natural selection).

It is, then, positivism in science and social Darwinism in social thought that marked the framework within which photography was applied to the task of constructing new forms of social inventory in the nineteenth century. Such philosophies found fertile ground in a context in which the rapid industrialisation of Europe and North America was accompanied by an accelerating process of social change which threw up new organisations, occupations and social groups.

Pursuits such as medicine and the law, which had been practised by people of both high and low status in the eighteenth century, were intensively professionalised in the first half of the nineteenth century, and became distinctly

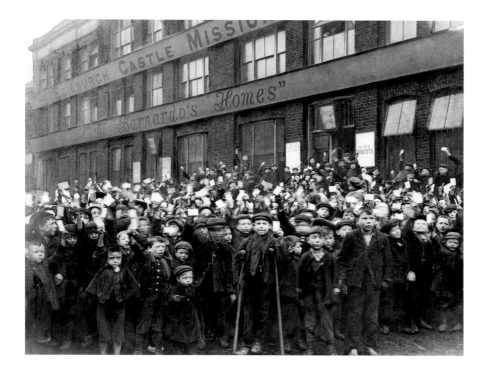

fig.99 Unknown photographer
Ragged School, *c.* 1860
Lantern slide
© Barnardo's Photo and Film Archive

'middle-class' professions as this class itself emerged as a new and expanding social grouping around white-collar and black-coated occupations. The visual markers of class, prestige, status or esteem were in a constant process of flux, as social and economic development reshuffled the pack. Trade and manufacture resulted in new elites which challenged the hegemony of the aristocracy; universalism replaced patronage and nepotism, as rational bureaucratic principles began to infuse the new 'Civil Service'. Universities became centres of learning rather than clerical retreats. In the complex new society which was emerging, old signifiers of social position were eroded. All of this goes some way to explain the fascination with portrait photography, and particularly its use as a means of grasping and fixing social position from within the turbulent flow of change.

Social portraiture then, and its counterparts in science, medicine and the judiciary, offered 'parallel' and related forms of surveillance; photography was used to highlight the existence of classes, categories and types of people. Indeed, what is even more striking is the way in which these practices displayed so many apparent similarities, their only differentiation being the manner in which they were rooted in specific institutions. Hugh Diamond, for instance, made numerous portraits in the 1850s of his illustrious peers, members of the medical and scientific professions, fellow founders of the

fig.100 Unknown photographer
Gallery School, London
Albumen print
© Metropolitan Archives, London

fig.101 Unknown photographer
Buckingham Street School, London, 1906
Silver print
© Metropolitan Archives, London

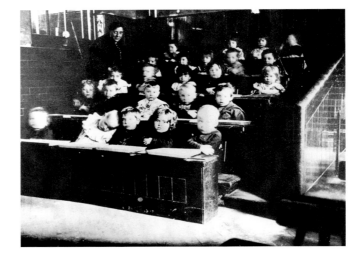

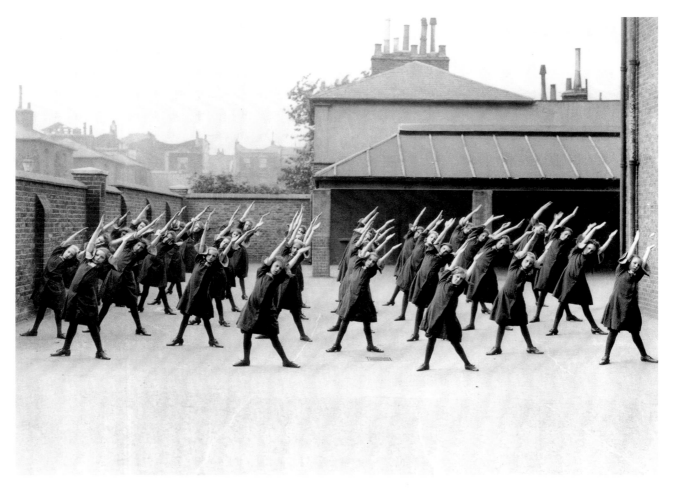

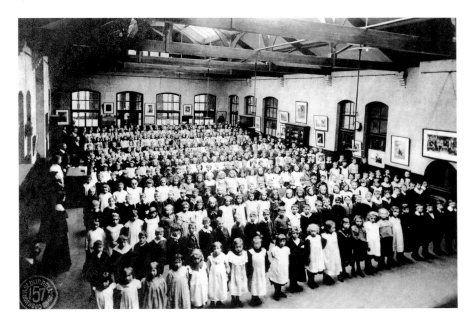

fig.102 Unknown photographer
Rosendale Road School, London, c. 1900
Silver print
© Metropolitan Archives, London

(figs 99–102) This sequence of school-group photographs graphically illustrates the rapidly changing role which education played in shaping a new society. Education became indelibly linked to both social justice and the notion of self-improvement. In 1828 Tom Arnold became headmaster of Rugby and began reforming the founding principles of education for the sons and daughters of the middle classes. At the other end of the social scale, a series of Factory Acts legislated against the exploitation of child labour. In 1844 Lord Shaftesbury organised the first Ragged Schools for the poorest children. The Education Act of 1870 paved the way for a system of universal schooling, and by 1880 schooling became compulsory for children aged 5–10. The group photograph became the dominant visual code for expressing institutional identity. Modern published biographies of celebrated personalities inevitably reproduce school-group pictures, underscoring the emergence of the individual from its position of anonymity within the collective body.

Photographic Society. They are fine examples of the art, owing much to the conventions of the era, but given an intriguing twist: Diamond helped to develop the wet collodion negative system with his colleague Frederick Scott Archer, and, perhaps because of his expertise, was able to make finely detailed and technically beautiful prints from the images which resulted – these would be enough to make him a notable, if minor, photographer even if we knew nothing of his portraits of 'the insane', those remarkable images of the paupers and social outcasts present in the Surrey Asylum. He turned his camera lens on them not, as he might have done, to make character studies of the poor individuals in his care, but with an emanci- patory social purpose, to contribute to their treatment within a system only recently humanised by the application of science. Yet, despite their benevolent intent, Diamond's photographs may also be interpreted as part of an emergent system of scrutiny through the camera lens – an early, if faltering, step in the direction of a system of classification in which it would be possible one day to see the insane as examples of racial degeneracy, as a group which must be eugenically controlled so that it does not dilute the racial line. One conclusion frequently drawn from this is that photography, by its employment within such new systems of discipline, treatment and control, became a sort of adjunct to the power structures of nineteenth-century societies. Indeed, it cannot be disengaged from them.

While it is important to understand how a technology such as photography played a part in the exercise of power, it is also important to remember that

fig.103 Benjamin Stone
Clock Face, Big Ben
Platinum print
National Portrait Gallery (x25567)

Sir Benjamin Stone was the
Conservative MP for Birmingham
East and an enthusiastic amateur
photographer. During his fourteen
years in Parliament he sought to
photograph every Member and
employee of the House of the
Commons and made numerous
studies of visitors.

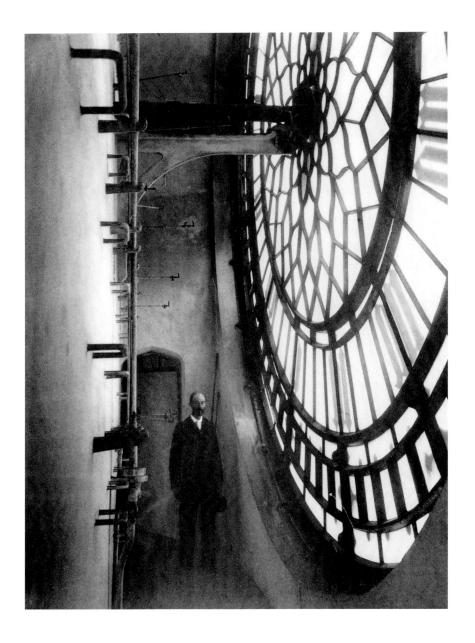

photography in the nineteenth century offered new and sometimes emancipatory
images both of society and of the individual within it. Such pictures were not
available before photography, and in a very real way they offered ways of
visualising things which had not been 'seen' hitherto, thus helping to 'envisage'
social and other entities not apparent before. Although the evidential quality
of the photograph immediately suggests its role within systems of social

Alphonse Bertillon was brought up
in an environment where order and
classification were coming to be seen as
essential to the creation of a scientific
and rational social regime. After 1871
and the establishment of the Third
Republic, science and education were
given considerable support by the
new regime.

control, we tend to ignore in this how it may also enable and emancipate by
informing and witnessing (principles dear to modern photo-journalism).
Although not touched on in this book, a further subject might be suggested,
that the extensive (but 'hidden') use of photography to circulate erotic and
pornographic images in the nineteenth century helped to inform people about
sexuality, much in the same way as illustrated sex manuals have done, albeit
more openly, in the late twentieth century.

It may almost be a cliché to suggest that the practice of photography within
many different spheres of life, as a device to record and transmit socially
important information about individuals, has played a critical part in
emergent ideas about individuality, personality and character. In certain
contexts this made it easier for some organisations to control others, to
exercise power and authority over them; but in other contexts, we might see
photography playing another role, in which it is the individual whose life and
existence is enhanced. On the one hand, then, we see portrait photography
and its virtues – which include the socially beneficial role it plays in defining
beauty, safeguarding memory and transmitting emotion across the boundaries
of distance and even death – and on the other we see its role as a servant to
systems of classification designed to control and restrict but also, paradoxically,
to cure and to heal. The intimacy of relation between these facets of
nineteenth-century portrait photography makes them difficult to distinguish,
but at the same time enormously absorbing to study.

Bibliography

Arnold, H. J. P., *William Henry Fox Talbot: Pioneer of Photography and Man of Science*, Benham: Hutchinson, 1977

Balwin, Gordon and Keller, Judith, *Photography and Fame, The J. Paul Getty Museum, Los Angeles*, Paris and New York: Nadar Warhol, 1999

Batchen, Geoffrey, *Burning with Desire*, Cambridge, Mass.: MIT Press, 1997

Batut, Arthur, *L'Application de la Photographie à la Production du Type d'une Famille, d'une Tribu ou d'une Race*, Paris: Gauthier Villars, 1887

Bell, Charles, *Essays on the Anatomy of Expression in Painting*, London: George Bell and Sons, 1806

Bennett, Tony, 'Pedagogic objects, clean eyes, and popular instruction: On sensory regimes and museum didactics', in *Configurations*, 1998, vol.6, pp.345–71

Bertillon, Alphonse, *Instructions sur la Photographie judiciaire*, Paris: Éditions Bailland, 1892

Briggs, Asa, *Victorian Portrait: Victorian Life and Values as Seen Through the Work of Studio Photographers*, London: Cassell, 1989

Bula, Sandrine and Quétin, Michel, 'Duchenne de Boulogne et le prix Volta', in ENSBA, *Duchenne de Boulogne 1806–1875*, Paris: École nationale supérieure des beaux-arts, 1999

Burrows, Adrienne and Schumacher, Iwan, *Portraits of the Insane: the Case of Dr Diamond*, London: Quartet Books, 1990

Bush, M. L. (ed.), *Social Orders and Social Classes in Europe since 1500*, London and New York: Longman, 1992

Cazort, Mimi, 'Photography's illustrative ancestors: the printed image', in Ann Thomas (ed.), *Beauty of Another Order*, New Haven and London: Yale University Press, 1997

Cowling, Mary, *The Artist as Anthropologist*, Cambridge: Cambridge University Press, 1989

Cuthbertson, R. Andrew (trs. and ed.), 'The highly original Dr. Duchenne', in G.-B. Duchenne de Boulogne, *The Mechanism of Human Facial Expression*, Cambridge: Cambridge University Press, 1990

Darwin, Charles (1872), *The Expression of Emotions in Man and Animals*, with introduction, afterword and commentaries by Paul Ekman, London: Fontana Press, 1999

Duchenne de Boulogne, G.-B., *Album de photographies pathologiques complémentaires du livre intitulé De l'électrisation localisée*, Paris: J.-B. Ballière, 1862
Mécanisme de la physionomie humaine, Paris: J.-B. Ballière, 1862
(1862) (R. Andrew Cuthbertson trs. and ed.), *The Mechanism of Human Facial Expression*, Cambridge: Cambridge University Press, 1990

Edwards, Elizabeth, *Anthropology and Photography 1860–1920*, New Haven and London: Yale University Press, 1992
'Photography and Anthropological Intentions in Nineteenth-Century Britain', in *Revista de Dialectología y Tradiciones Populares*, T. III, 1998

ENSBA, *Duchenne de Boulogne 1806–75*, Paris: École nationale supérieure des beaux-arts, 1999 (see also Bula, Sandrine)

Foucault, Michel (1963), *The Birth of the Clinic: an Archaeology of Medical Perception*, New York: Vintage Books, 1975
(1975) *Discipline and Punish: the Birth of the Prison*, London: Allen Lane, Penguin Press, 1977

Frizot, Michel (ed.), *A New History of Photography*, Cologne: Könemann, 1998
et al., *Identités, de Disdéri au Photomaton*, Paris: Photo Copies, 1985

Galton, Francis, 'Composite Portraits' in *Journal of the Anthropological Institute*, vol. VIII

Gernsheim, Helmut, *The Origins of Photography*, London: Thames and Hudson, 1982
The Rise of Photography 1850–1880, London: Thames and Hudson, 1988

Goldberg, Vicki (ed.), *Photography in Print*, Albuquerque: University of New Mexico Press, 1981

Haworth-Booth, Mark, *Camille Silvy, River Scene, France*, Los Angeles: The J. Paul Getty Museum, 1992

Hayes, John, *The Portrait in British Art*, London: National Portrait Gallery, 1991

Heffer, Simon, *Moral Desperado: A Life of Thomas Carlyle*, London: Weidenfeld & Nicolson, 1995

Henisch, Heinz K. and Henisch, Bridget A., *The Photographic Experience 1839–1914*, Pennsylvania: Penn State Press, 1994

Jay, Bill, *Cyanide and Spirits: An Inside-Out View of Early Photography*, Munich: Nazraeli Press, 1991

Kemp, Martin, 'A perfect and faithful record: mind and body in medical photography before 1900' in Ann Thomas (ed.), *Beauty of Another Order*, New Haven and London: Yale University Press, 1997, pp.120–49
and Wallace, Sandra, *Spectacular Bodies*, London: The Hayward Gallery and California University Press, 2000

Laslett, Peter, *The World We Have Lost* (2 edn.) London: Methuen, 1971

Lavatar, Johann Kaspar, *Essays on Physiognomy*, London: Ward Lock & Co, n.d.

Linkman, Audrey, *The Victorians: Photographic Portrait*, London: Taurus Parke Books, 1993

McCauley, Elizabeth Anne, *A.A.E. Disdéri and the Carte de Visite Portrait Photograph*, New Haven and London: Yale University Press, 1985
Industrial Madness: Commercial Photography in Paris 1848–1871, New Haven and London: Yale University Press, 1994

Panzer, Mary, *Mathew Brady and the Image of American History*, Washington D.C.: Smithsonian Institution Press, 1997

Phéline, Christian, 'Portraits en règle', in Michel Frizot, et al., *Identités, de Disdéri au Photomaton*, Paris: Photo Copies, 1985

Pick, Daniel, *Faces of Degeneration*, Cambridge: Cambridge University Press, 1989

Pointon, Marcia, *Hanging the Head*, New Haven and London: Yale University Press, 1993

Prescott, Gertrude, 'Fame and Photography: Portrait Publications in Great Britain, 1856–1900', dissertation, The University of Texas at Austin, 1985

Prodger, Phillip, 'Photography and the expressions of the emotions', Appendix III, pp.399–410, in Charles Darwin, *The Expression of the Emotions in Man and Animals*, 1872, with introduction, afterword and commentaries by Paul Ekman, London: Fontana Press, 1999 (see also Darwin, Charles)

Rogers, Malcolm, *Camera Portraits: Photographs from the National Portrait Gallery 1839–1989*, London: National Portrait Gallery, 1989

Ruby, Jay, *Secure the Shadow, Death and Photography in America*, Cambridge, Mass.: MIT Press, 1995

Ryan, James R. *Picturing Empire: Photography and the Visualisation of the British Empire*, London: Reaktion Books, 1997

Seed, John, 'From "middling sort" to middle class in late eighteenth- and early nineteenth-century England', in M.L. Bush (ed.), *Social Orders and Social Classes in Europe since 1500*, London and New York: Longman, 1992, pp.114–35

Small, Hugh, *Florence Nightingale: Avenging Angel*, London: Constable, 1999

Sobieszek, Robert A., *Ghost in the Shell: Photography and the Human Soul, 1850–2000*, Los Angeles: LACMA, 2000

Talbot, William Henry Fox, *A Brief Description of the Photogenic Drawings Exhibited at the Meeting of the British Association, at Birmingham, in August 1839, by H.F. Talbot Esq*, 1839 in Weaver, Mike (ed.) *Henry Fox Talbot: Selected Texts and Bibliography*, Oxford: Clio Press, 1989
The Pencil of Nature, London: Longmans, 1844–6

Thomas, Ann (ed.), *Beauty of Another Order*, New Haven and London: Yale University Press, 1997

Thorn, Michael, *Tennyson*, London: Little Brown and Company, 1992

Trachtenberg, Allan, 'Likeness and Identity: Reflections on the Daguerrean Mystique' in *The Portrait in Photography* Graham Clarke (ed.), London: Reaktion Books, 1992

Zelizer, Viviana A., *Pricing the Priceless Child: The Changing Social Value of Children*, New York: Basic Books, 1985

BRITISH POLITICAL	WORLD POLITICAL	SOCIAL
1725–1810 1791–2 Thomas Paine's *Rights of Man* is published (in two parts) 1803 Britain resumes war with France 1805 Nelson defeats Franco-Spanish fleet at the Battle of Trafalgar 1807 Abolition of the slave trade	1776 Declaration of American Independence 1789 French Revolution	1782 First Sunday School established 1785 Foundation of *The Times* as the Daily Universal Register 1801 Beginnings of the Voluntary School Movement. First national census of UK population
1811–20 1815 Enactment of the Corn Laws 1820 Death of George III	1812–5 Anglo-American War 1815 Battle of Waterloo	1811–2 Outbreaks of Luddite machine-breaking 1819 Peterloo massacre in which eleven are killed during Reform demonstrations. Poor Relief Act enables parishes to form Poor Law Committees. Factory Act prohibits children under the age of nine working in mills
1821–30 1830 Death of George IV	1821–9 Greek War of Liberation 1830 Independence of Belgium (technically war began in 1830, Belgium's independence not recognised by the Dutch until 1839)	1828 Reverend Thomas Arnold becomes headmaster of Rugby School, thereby heralding the beginnings of Public Schools reform 1829 Metropolitan Police Act establishes a paid, uniformed police force 1830–42 Auguste Comte's *Cours de philosophie positive* which defines positivism is published
1831–40 1832 Reform Act extends enfranchisement 1834 Tolpuddle Martyrs sentenced to transportation to Canada for organising trade union activities 1840 Britain claims New Zealand as a colony (with the treaty of Waitangi). Chartist 'rising' in Dewsbury and Sheffield. Penny post introduced. Marriage of Victoria and Prince Albert	1834 *Zollverein* customs union prepares way for German unification 1837 Victoria accedes to the British Throne 1839 Opium Wars in China	1833 Factory Act provides education for child labourers 1834 Poor Law Amendment Act introduces the workhouse 1836 Stamp tax on newspapers is reduced 1839 Country Police Act establishes a paid county police force
1841–50 1842 Britain acquires Hong Kong 1846 Repeal of the Corn Laws	1841–71 (ended) Unification of Germany 1848 Revolutions in France, Germany and Italy. Louis Napoleon is elected President of the Second French Empire. Marx and Engels' *Communist Manifesto* is published 1850 California becomes the thirty-first state of the USA	1844 Ragged schools first organised 1845 Lunacy Act sets up Board of Commissioners for Asylums 1848 Public Health Act creates local Boards of Health
1851–60 1857–8 Indian Mutiny	1851 Louis Napoleon proclaims himself Emperor Napoleon III 1853–6 Crimean War	1851 Foundation of Reuters, the first news agency 1855 Repeal of stamp duty, opening up cheap press
1861–70 1861 Death of Prince Albert 1865 William Booth assumes leadership of what was to become the Salvation Army 1867 Reform Act further extends enfranchisement 1868 Establishment of Trades Union Congress	1861 Unification of Italy 1861–5 American Civil War 1862 Garibaldi marches on Rome 1869 Opening of the Suez Canal 1870–71 Franco-Prussian War	1867 Marx's *Das Kapital* is published 1868 Public Schools Act 1869 John Stuart Mill's *The Subjection of Women* is published 1870 Education Act creates new schools
1871–80 1874 Disraeli becomes Prime Minister for the second time 1875–8 Balkan Crisis 1876 Bill introduced to crown Queen Victoria Empress of India	1871 Establishment of the Third Republic in France. Paris Commune 1872 *Dreikaiserbund* unites Germany, Austria and Russia in pact 1878 Disraeli presides over the Berlin Congress to dismember the Ottoman Empire	1871 Trades Union Act grants unions legal status 1877 Annie Besant and Charles Bradlaugh acquitted after distributing contraceptive advice 1878 Foundation of the Salvation Army 1880 Frozen meat arrives in Britain
1881–90 1884–5 Reform and Redistribution Acts reform political boundaries and further extends enfranchisement 1886 Irish question brings down Gladstone's government 1887 Queen Victoria's Golden Jubilee	1881 Assassination of American President Garfield and Tsar Alexander II 1882 Formation of the Triple Alliance: Germany, Russia and Austro-Hungary. Jews flee pogroms in Russia 1885 Congress of Berlin agrees upon the partition of Africa 1887 Bismarck dissolves the *Reichstag* 1890 Kaiser dismisses Bismarck	1881–5 Revised version of the New Testament is published 1882 Education Act makes schooling for five- to ten-year-olds compulsory 1884 Fabian Society is founded 1889 Board of Education is established
1891–1900 1892 Keir Hardie, first Labour MP, is elected 1899 Boer War begins 1900 Free Church of Scotland and United Presbyterian Church unite	1893 Panama Canal scandal rocks France. Dreyfus first charged with treason, convicted 1894. 1894 USA claims Hawaii 1898 Spain cedes Cuba, Puerto Rico and Phillipines to USA (after losing the Spanish-American War)	1891 German Social Democrat Party adopts Marxism 1893 Education Act establishes special schools for blind and deaf children 1895 Oscar Wilde is imprisoned for homosexuality. Gas is established as basic fuel for heat and light
1901–10 1901 Death of Queen Victoria 1903 Women's Sufragette Movement begins	1904 Formation of the *Entente Cordiale* between France, Russia and Britain. Kaiser provokes Morocco crisis 1904–5 Russo-Japanese War	1902 Education Acts establish local education authorities with powers for secondary education 1904 *Daily Mirror* is the first newspaper to be regularly illustrated with photographs

PHOTOGRAPHY AND PRINTING	THE ARTS	SCIENCE/TECHNOLOGY
1725–82 First experiments with light sensitivity of silver and ferrous salts by Johann Schulze and Carl Scheele	1775–8 Johann Caspar Lavater's *Essays on Physiognomy* is published (translated into English in 1797)	1769 Invention of the modern steam engine by James Watt is patented
1802 Thomas Wedgewood's and Humphrey Davy's experiments with chemical transfer of light images	1791 Wolfgang Amadeus Mozart dies	1777 Invention of the 'Mule Jenny' fabric spinning by Samuel Crompton
1807 Invention of camera lucida by William Hyde Wollaston	1793 Jacques-Louis David executes *Death of Marat*	1785 Invention of the power driven loom by the Reverend Edmund Cartwright
	1794 William Blake executes *The Ancient of Days*	
	1808 Jean-Auguste-Dominique Ingres executes *The Valpinçon Bather*	1808 Joseph Gall's *The Functions of the Brain* is published
1816 Niépce brothers produce image in camera obscura using paper sensitised with silver chloride	1812 Birth of Charles Dickens	1814 First use of steam presses to print *The Times*
	1812–5 Grimm's *Fairy Tales* are published (in volumes)	1819 Invention of the stethoscope by René Laennec
	1813 Jane Austen's *Pride and Prejudice* is published	
	1814 Franciso Goya executes *Dos de Mayo*	
		1827 George Ohm formulated electrical law of resistance
1827 Joseph Nicephore Niépce makes first photograph on bitumen sheet	1821 John Constable executes *The Hay Wain*	1829 Invention of the railway locomotive by Robert Stephenson
	1824 Eugène Delacroix executes *Massacre at Chios* Ludwig van Beethoven composes the *Ninth Symphony*	1830 Michael Faraday discovers electromagnetic induction First railway line opened between Liverpool and Manchester
	1827–46 Frédéric Chopin composes *Nocturnes*	
1839 The Daguerreotype process announced in Paris Fox Talbot announces the Talbotype process in London. Hippolyte Bayard produces the first direct positive print	1835 Jean-Baptiste-Camille Corot executes *Forest at Fontainebleau*	1831 Invention of the dynamo by Michael Faraday
	1838–9 Charles Dickens' *Nicholas Nickleby* is published	1834 Joseph Henry built the first electric motor
		1835 Invention of the revolver by Samuel Colt
1840 Alexander Wolcott and John Johnson open the first portrait studios in New York		1837 Invention of the telegraphic code by Samuel Morse
1841 Fox Talbot patents the Calotype	1842 Joseph Mallord William Turner executes *Steamer in a Snowstorm*. Giuseppe Verdi composes *Nabucco*	1843 First use of electric telegraph for news gathering
1844–6 Fox Talbot's *The Pencil of Nature* is published		1846 Ether first used as anaesthesia by dentist William Morton (others used anaesthesia before this such as nitrous oxide)
1850 Mathew Brady's *Gallery of Illustrious Americans* is published in the USA	1850 Gustave Courbet advocates Realism in painting (demonstrated in *The Stone Breakers*)	
1850–51 Frederick Scott Archer invents the wet-collodion process		
1853 Photographic Society of London is founded (renamed Royal Photographic Society in 1894)	1851–2 Nathaniel Hawthorne's *The House of Seven Gables* is published	1851 The Great Exhibition opens in London
	1856–8 William Powell Frith executes *Derby Day*	1859 Charles Darwin's *The Origin of Species through Natural Selection* is published
	1857 Charles Baudelaire's *Les Fleurs du mal* is published	
1865 Walter Woodbury invents the Woodburytype	1859 Richard Wagner completes *Tristan and Isolde*	
1866 The carbon process is introduced after experiments by Mungo Ponton	1862 Édouard Manet executes *Déjeuner sur l'herbe*. Victor Hugo's *Les Misérables* is published	1861 Ignaz Semmelweiss discovered the cause of Puerperal fever
	1865 Lewis Carrol's *Alice in Wonderland* is published	1865 Joseph Lister introduced antiseptics into surgery
	1865–9 Leo Tolstoy's *War and Peace* is published	1867 Invention of dynamite by Alfred Nobel
	1870 Death of Charles Dickens	Invention of reinforced concrete by Joseph Monier
1871 Invention of the bromide print by George Eastman		
1878 Introduction of the dry plate process after various experiments	1872 James McNeill Whistler executes *Arrangement in Grey and Black*	1876 Invention of the telephone by Alexander Graham Bell
1880 Half-tone print process first used in the *New York Daily Graphic*	1872–3 Claude Monet executes *Impression: Sunrise* (a series of paintings)	1877 Invention of the phonograph by Thomas Edison
	1875 Georges Bizet composes *Carmen*	
	1877 Emile Zola's *L'Assommoir* is published	
1888 Invention of focal plane shutter by Anschutz allows instantaneous photography. George Eastman invents Kodak camera using roll-film	1883 Johannes Brahms composes the Second Piano Concerto	1882 Tuberculosis bacillus discovered by Robert Koch
	1885 Paul Cézanne executes *L'Estaque*	1883 Invention of the machine gun by Hiram Maxim (although other types of machine guns were around before this – used in the American Civil War). Diptheria bacillus discovered by Theodor Klebs and Friedrich Löffler
1890 Richard Maddox invents the first gelatin silver printing papers	1887 Pierre-Auguste Renoir executes *Les Grandes Baigneuses*	
1890–1904 Invention of the first modern lenses (e.g. Zeiss Tessar)	1888 Johan Strindberg's *Miss Julie* is published	1884 Gottlieb Daimler independently originated a petrol engine
		1886 Karl Benz designs his first motor car
		1888 Electromagnetic waves identified by Heinrich Rudolph Hertz
1900 Kodak manufactures the Brownie camera		
	1892 Henri de Toulouse-Lautrec executes *Aristide Bruant*	1895 X-rays discovered by Wilhelm Rontgen
	1893 Edvard Munch executes *The Scream*	1900 Inaugral flight of Count Zeppelin's *Dirigible* Sigmund Freud's *The Interpretation of Dreams* is published. Quantum theory proposed by Max Planck
	1894 Achille-Claude Debussy composes *L'Après-midi d'un Faune*	
	1897 André Gide's *Fruits of the Earth* is published	
1904 Louis Lumière manufactured the autochrome as the first commericially available colour process in France	1898 Auguste Rodin executes *The Hand of God*	
	1907 Pablo Picasso executes *Les Demoiselles d'Avignon*	1903 Marie Curie wins the first Nobel Prize. Wright Brothers complete the first aeroplane flight
	1908 Edward Elgar's composes the *First Symphony* (in A Flat)	1905 Theory of Relativity formulated by Albert Einstein
	1909 Filippo Tomasso Marinetti publishes the first Futurist manifesto	
	1910 Serge Diaghilev presents *Les Ballets Russes*	

Glossary

Albumen print: A print made using albumen paper introduced by L. D. Blanquart-Evrard in 1850. Albumen paper was the most popular photographic printing material in the nineteenth century. Paper was coated in a solution of egg white and salt and sensitised in a solution of silver nitrate. Prints were often toned with gold solution, giving a rich purple-brown to the image. The whites in the print tend to yellow with age.

Ambrotype: A form of collodion positive. In 1852 it was discovered that when a glass collodion negative was developed and bleached, it appeared as positive when set against a dark background. Ambrotypes were promoted by commercial studios as a cheap alternative to the daguerreotype.

Bromide print: A print made using paper sensitised with silver bromide. The paper was first produced commercially *c.*1880, and became the most popular and widely used photographic paper in the twentieth century, produced in a range of finishes – matt, semi-matt and glossy.

Cabinet print: Cabinet prints were introduced in 1865 as a larger, 16.5 × 10.8 cm, version of the *carte de visite*. Originally devised for landscape photography but quickly taken up by portrait photographers, the format had all but disappeared by *c.*1910.

Calotype: A process invented and patented by W. H. Fox Talbot in 1840. High-quality writing paper was sensitised with potassium iodide and silver nitrate solutions, and exposed in the camera. The paper negative was processed, then printed onto salted paper. The calotype formed the basis of later developments in negative-positive photographic processes, but never attained the commercial success of the rival daguerreotype process.

Carbon print: In 1855 A. L. Poitevin patented the carbon process, the first to produce prints that were permanent and would not fade over time. Paper coated with a gelatin containing a carbon black pigment was exposed under a negative in daylight. The paper was then washed to remove the soluble gelatin, leaving the residue carbon image. The process was popular between *c.*1870 and *c.*1900. Julia Margaret Cameron was an enthusiastic practitioner of the process.

Carte de visite: In 1854 André Adolphe Eugène Disdéri patented the *carte de visite* – a small print mounted onto sturdy card, the size of a visiting card, 10.1 × 6.3 cm. Disdéri devised a camera with multiple lenses and a rotating back that could make between four and ten exposures onto one glass-plate negative, thereby allowing for multiple printings and mass circulation of images. The *carte* process was hugely popular around the 1860s.

Collodion process or wet plate: Invented by Frederick Scott Archer in 1851, the 'wet plate' was the most popular form of photography until the 'dry plate' of the 1880s. A sheet of glass coated in collodion was exposed in the camera and developed while still wet. The process combined the sharpness of the daguerreotype with the calotype's ability for reproduction, and made for quicker exposures.

Daguerreotype: The first published photographic process, invented in France in 1839 by L.J.M. Daguerre. The invention derived from experiments made with Niépce since the 1820s. It comprised a copper plate with a polished silver surface sensitised by iodine fumes, exposed in a camera, and the image developed over heated mercury vapour. There is no negative, rather a reversed and unique plate mounted behind protective glass in decorative cases. In the early years of the process, exposure times were as long as twenty minutes. This was reduced to seconds, and in time the process became popular with portraitists.

Gum-bichromate process: Introduced in 1858, the gum-bichromate process involved the daylight contact-printing of a negative onto paper coated with a solution of gum arabic, pigment, colloid and a dichromate. The print was then washed to reveal tones of pigment and then re-sensitised and exposed again under the same negative. The prints have a painterly surface and texture and a rich tonal range. The process was particularly popular amongst the 'pictorialist' photographers who worked around 1890.

Photogravure: A process made commercially available in 1879 by Karl Kilc of Vienna, following on from earlier innovations in photomechanical printing processes developed by W.H. Fox Talbot in 1858. It was, in essence, an etching process with affinities with the carbon-print process, and was used for the high-quality reproduction of art photographs in the 1890s and 1900s.

Platinum print: A print made with paper sensitised with iron-salts, but no silver, and a platinum compound. The process was invented in 1873 by William Wills and made commercially available in 1879. The resulting prints, also known as platinotypes, are stable and permanent, with a distinctive matt finish and broad range of grey tones, approximately twice those of silver prints. A dramatic rise in the price of platinum after 1918 lead to the decline of the process.

Salt-paper process: The process first used by W.H. Fox Talbot for his 'photogenic drawings' as early as 1834, and later used to print from calotypes and other negatives. The print was made on high-quality writing paper that has been immersed in a solution of common salt and then floated in a bath of silver nitrate. The process was superseded in the 1850s by albumen prints, but underwent a revival in the 1890s and early 1900s.

Silver prints or gelatin silver prints: Introduced into general use in the 1880s and the most common form of photographic paper up to the present day, these prints are made with silver halides suspended in a layer of gelatin on fibre-based paper. Prints are developed using the three-bath chemistry of developer, stop and fixer, and can be chemically toned to alter the finished look of the print.

Woodburytype: Invented in 1864 by W.B. Woodbury, the woodburytype is a photo-mechanical reproduction which closely resembles the gelatin silver print. The process was used for high-quality series and edition prints with emphasis placed on the permanence of the image, but was discontinued around 1900 due to its high costs.

Index